THE ART AND ATTITUDE OF
COMMERCIAL
PHOTOGRAPHY

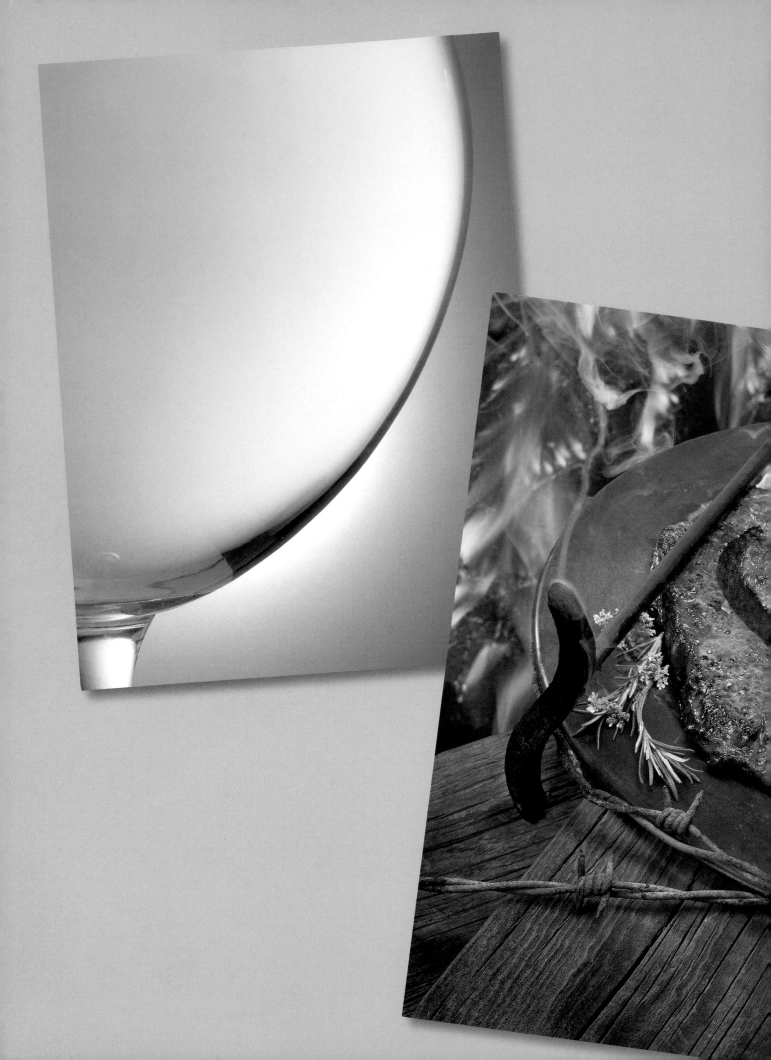

THE ART AND ATTITUDE OF
COMMERCIAL
PHOTOGRAPHY

Rick Souders

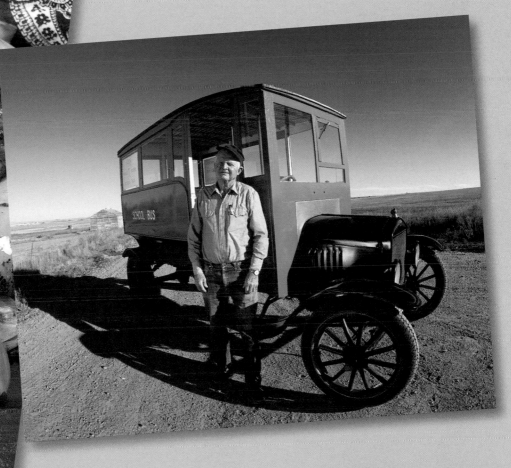

AMPHOTO BOOKS
An imprint of Watson-Guptill Publications
New York

Acknowledgments
I would like to thank the following individuals for their contributions to this book and for their inspiration: Lloyd and Betty Souders (my parents and the models in some of the photographs); John Wood, Wood Photography (contributing photographer and digital composite artist, creator of all the book's lighting diagrams); Selina Oppenheim; Trevor Moore (contributing photographer, studio manager of Souders Studios); Steve Setlik (contributing digital composite artist); Josh Barrett (contributing photographer; student intern); Jan Lederman of Mamiya America Corporation; Allison Lucernoni (copy editor); Mila Dosien (make-up, wardrobe, and prop stylist); Rob Lail (proprietor of Maximum Talent, Denver, CO); Steven Shern (lead creative food stylist); Jacquelin Buckner (contributing food stylist); Christelle Newkirk (national photography rep. for Souders Studios). I would also like to thank all the models who appear in this book.

Senior Acquisitions Editor: Victoria Craven
Edited by Elizabeth Wright
Designed by Jay Anning
Production Manager: Hector Campbell

First published in 2002 by Amphoto Books,
an imprint of Watson-Guptill Publications,
a division of VNU Business Media, Inc.,
770 Broadway, New York, NY 10003
www.watsonguptill.com

Library of Congress Control Number: 2002104780

ISBN 0-8174-3309-0

Printed in Italy

First Printing, 2002

1 2 3 4 5 6 7 8 9 / 09 08 07 06 05 04 03 02

CONTENTS

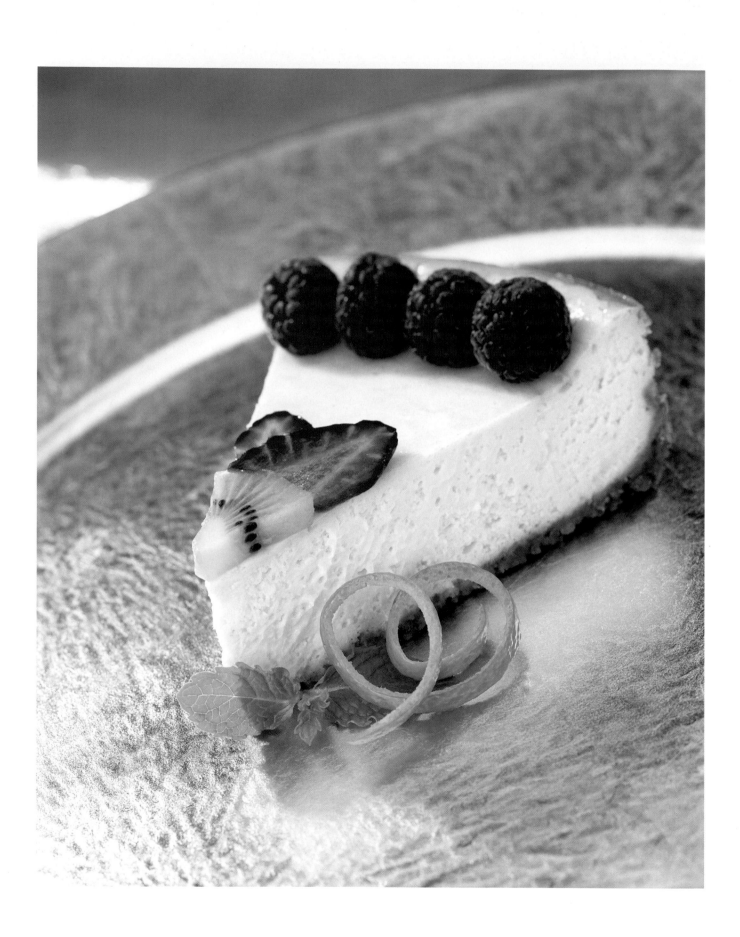

Foreword

The Art and Attitude of Commercial Photography is one of the first books of its kind to address photography from a visual as well as a business perspective. Indeed, it is critical for photographers in today's market to consider both areas when developing their business. I am thrilled that Rick Souders has chosen this as his topic because I know how truly needed this information is.

As a consultant to photographers, my job for the past 20 years has been to help my clients determine their creative, financial, and professional goals. I work with talent, helping artists to develop and implement programs that will enable them to reach the goals that they have set. In this capacity, I have had the opportunity to work with photographers from all over the United States, Canada, Mexico, and London. I have worked with some of the top shooters in our field and have also consulted with those just beginning their quest.

While each of my clients comes to me with a different set of goals and level of talent, all need to understand and accept the same fact: what they need to package and brand is their particular attitude and way of seeing. This understanding, combined with professional ethics, a knowledge of business practices, and superior client service, determine a photographer's success.

Photographers in today's market have many opportunities that others before them never had. One of the key benefits of working today is the photographer's opportunity to develop a business based on his/her specific talent and vision. Years ago this was not possible. In order to develop a healthy client base, photographers were forced to be generalists. Regardless of their photographic interests and individual talents, they needed to be jacks of all trades. They may have found themselves shooting product one day and fashion the next. They packed up for a corporate location shoot one week and welcomed a client into their studio for a food shot after that. But today, that has all changed because photographers can now choose to work in their field of interest, however specific or broad that may be.

Due to an overcrowded market and the many options that buyers can use to purchase photography (stock images as well as royalty free); clients now look at the photographer's style or vision when assigning a project. Lensfolk are chosen for an assignment based on the visual value that they bring to a project. Contrary to popular myth, this habit of buying talent, not technique, doesn't only happen in large markets like New York, Los Angeles and Chicago. It happens everywhere.

While some photographers complain that this "new" buying habit restricts their business development, what it actually does is provide an opportunity for their creative and personal growth. It asks that photographers reflect on their interests and develop their talents as they apply to their target market needs. In addition, this new attitude requires photographers to market their visual as well as their service value. Marketing your vision entails the creation of specific tools such as a portfolio, direct mail materials, and a Web site. All of a photographer's advertising and marketing efforts must define his/her vision but also apply to the needs of his/her audience. That is no easy task, and Rick Souders speaks from great experience as he describes how to tackle the job. I know that Rick has a tremendous amount of knowledge to share, as he and I have worked closely together for several years developing the tools that have helped his business become successful. Rick has truly seized the opportunities of today's market to showcase his talent.

It is such opportunity, the chance to show who you are as an artist and a businessperson, that makes Rick Souders' book so timely. *The Art and Attitude of Commercial Photography* covers all the bases. Successful businesses have always contained a strong, carefully planned service component. For photographers, the approach should be no different. An awareness of clients' needs and a commitment to produce the best shot in the most client-comfortable environment must be the primary components of the service they provide. In addition, they must decide which business practices they are going to adhere to. In my experience, this is one area in which most photographers falter. If you aspire to be a successful commercial photographer, read Rick's words carefully and determine for yourself what your service ethic will be.

In closing, I welcome you to the world of positive thinking, intelligent strategic planning, superior client service, and focused talent—in essence, I welcome you to the world that is Rick Souders'. Rick is one of the most successful photographers I know. He has created his own set of goals and determined his own set of values for his business. He continually meets his goals and sets new ones. His drive, positive spirit, work ethic, and talent are an unbeatable combination. You now have the unique opportunity to learn from a photographer who believes that excellence doesn't begin and end with just a printed photograph.

As you read the information contained in *The Art and Attitude of Commercial Photography,* open your mind and your spirit. Success in the world of commercial photography is not just about talent, it is also about business and the heart!

Selina Oppenheim
President, Port Authority, Inc.
www.1portauthority.com

Introduction

When I was approached to write this book, I asked myself, "What new information can I contribute to the world of commercial photography?" The answer was simple. I could put together a book that talked about commercial advertising photography from a unique, practical perspective. After doing some research, I found a few specialized books out there, but none that took on the challenge of addressing the whole package of the commercial realm in general. I wanted to write a book that would motivate novices to move forward and also provide a jump-start to working photographers who were burned out, in need of some fresh inspiration, or who just wanted to collect another photo book.

My acquisitions editor, Victoria Craven, told me in one of our first discussions, "We like your photography, your unique attitude, and your approach to business." With that in mind, I determined that while I could share some helpful photographic techniques, it was more worthwhile to write about what I call "attitude" and the importance of business strategy. This unique book will give you the basic information you need to get started in the commercial photography market. Most importantly, however, I hope it will teach you to communicate your uniqueness and your vision and integrate them with your approach to business to enjoy fulfillment and success in this crazy industry. I hope some of my attitude will rub off on you and inspire you. The four words that really sum up the contents of this book are: vision, tenacity, attitude and perseverance.

If you get one thing out of this book, I hope it is the belief that you can turn doing something you enjoy into a career that fulfills and inspires you.

Don't put another job into your life—put some life into your job!

Happy reading,

RICK SOUDERS,
Souders Studios

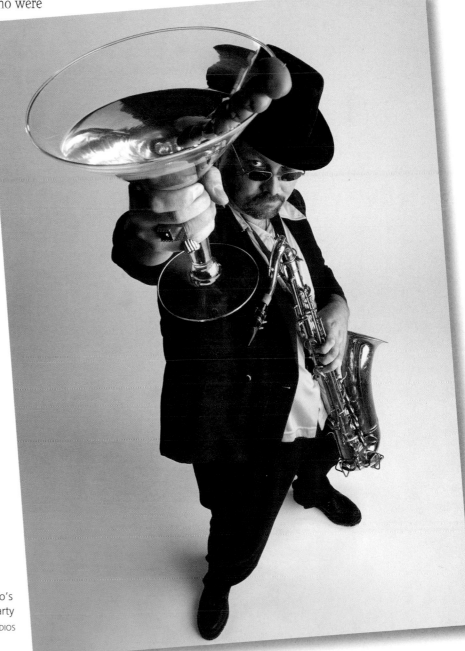

Portrait taken for the studio's annual client martini jazz party

TREVOR MOORE © SOUDERS STUDIOS

What Is Commercial Photography?

Everywhere we look, we see images in print, such as those in magazines, in-store ads, and product packaging, or moving images such as those in movies or television. These make up a large and lucrative segment of professional photography known as commercial, or advertising, photography.

Commercial photography can encompass many media and market segments, but it can still be simply defined as photography that conveys a message used to sell a product or a service or that instigates some action on the part of the viewer. Images are used to stimulate our senses, causing us to react positively to the product. Images designed to appeal to our sense of taste, such as a juicy hamburger or a cold, frosty soda, prompt us to be hungry or thirsty and, hopefully, to make a purchase to satisfy that hunger. The concept is the same no matter what the product is. Charities use powerful photographs to provoke emotional responses—to make us feel sorrow or anguish, and to provoke us to make a difference with our donations.

Motivation: In Your Photographs and in Your Life

Visual images have the power to shape our world. They can build companies and help drive the stock market. Visual images can change the way we live and the way we interact with each other. They can even influence the life-changing decisions we make about our health. And, in this evermore visual universe, commercial images are just a mouse-click away on the Internet, which acts to bring the world closer and closer together every day. The magnitude and importance of commercial photography's impact on our lives is indeed overwhelming.

If you are a person who has always been intrigued by visual images, a person who looks at light a little differently than others do, or a person who wants to know about how the visual effects you see were created, then commercial photography could be a great career for you to look into. If you are the kind of person who goes to get a snack or a drink during the actual Super Bowl game, but you make sure to be firmly planted in front of the TV when the high-dollar commercials are on, you might be the kind of person who could get hooked on this profession in no time. There are a number of ways to get started in the business, and if you are already a photographer, there are many ways you can further advance your career.

Preliminary Research

Figuring out how to get started or how to give your existing career a jump-start might seem overwhelming at first, but it is actually not as difficult as it may initially appear. Many different avenues can help take you where you want to be. If you don't know where that is yet, don't worry: one of this book's objectives is to help you find out.

PHOTOGRAPHY CLASSES

Attending a photography school or taking courses in photography are both important routes to consider. You can take evening classes on lighting and other aspects of commercial photography and still maintain your daytime work schedule, or you can enroll in a two- or four-year college program and earn an associate or bachelor's degree in commercial photography. Most community colleges offer photography classes, as do most universities or other community adult-learning programs. Pursuing a college degree in photography is an excellent idea if you have the time and resources to do so. Remember though that like in any field, there are many self-taught great masters out there. If you don't enroll in a degree program, evening classes, workshops, and weekend and weeklong seminars are wonderful opportunities for newcomers to begin learning or for working professionals to give themselves a fresh approach to their work. As with any new interest you want to explore, you should do some preliminary research, ask a few questions, and find the right seminars or programs for you. Looking at the Web sites of programs that interest you can make the process even simpler. You can do research at your own pace. Information on all legitimate photography schools and organizations, unless they are very new or very small, can usually be found on the Internet.

PROFESSIONAL ORGANIZATIONS

Joining a professional photography organization such as the American Society of Media Photographers (ASMP), the Advertising Photographers of America (APA), or the Professional Photographers of America (PPA), is an excellent way to familiarize yourself with the field. Many of them offer educational seminars and newsletters and also provide opportunities for meeting and talking to professionals in the field. Each organization has different membership criteria. You can attend meetings as a guest and thereby check out the program and the caliber of the photographers who are members. Talk to them and find out if the organization is right for your interests, schedule, and needs. Again, you can do a lot of research about such organizations on the Internet. Most photography organizations offer different levels of membership. For example, you can join the American Society of Media Photographers at a very reasonable student discount rate or as an affiliate member.

PUBLICATIONS

Books, magazines, and other publications are important resources for newcomers to the industry and for seasoned professionals. Reading them keeps you informed about new trends in photography and "how to's" regarding technique and lighting styles. You can

Little Girl For Make A Wish Foundation Campaign
© Rick Souders

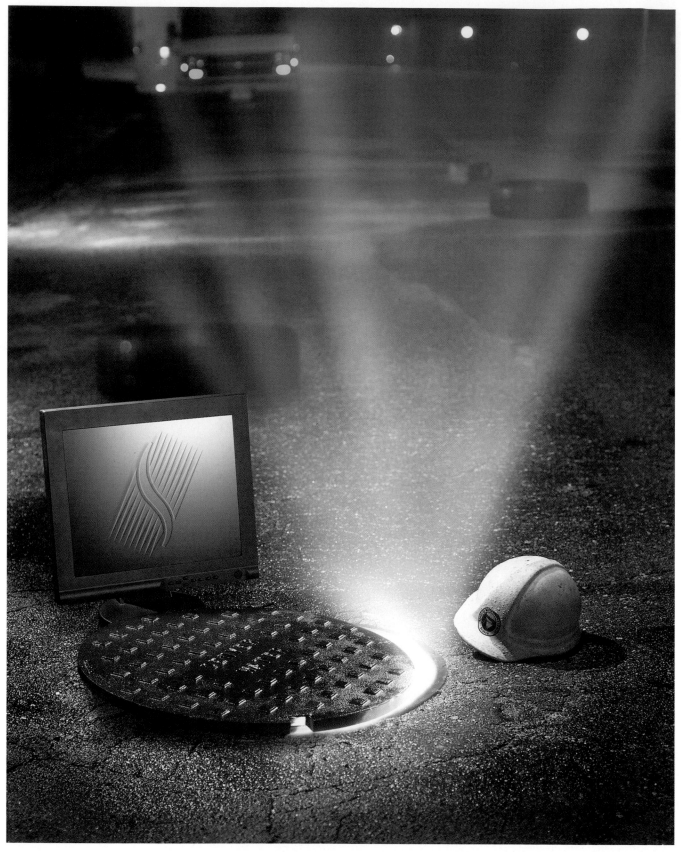

MANHOLE COVER
© RICK SOUDERS

I created this photograph of a glowing manhole cover for a print ad campaign. I took three images and digitally combined them to make one surreal shot.

learn about specialized segments of the commercial photography market, and you can get the inspiration to create exciting visuals of your own. The fact that you are reading this book, actually, is a sign that you are already on the right track.

ASSISTANTSHIPS AND INTERNSHIPS

Assisting a professional photographer in a studio is an invaluable educational experience. If you are just starting out, I strongly recommend that you spend as much time as a photographic assistant in a commercial studio as possible. When you approach a photographer about working for him/her, you need to be honest about your skill level. If you are a student with some photography skills such as basic lighting, film loading, or general camera capabilities, you may be able to find an internship with a photographer who will let you work one or two days a week while you are in school. If you have little or no experience, you can still try to get into a studio to see what the photographer is shooting and to ask a few questions. In large markets, most big-name studios have a studio manager in charge of running the studio for a photographer. This person helps prepare for shoots, helps set up lighting and sets, orders and monitors supplies, and takes care of numerous other matters to ensure that the business runs smoothly. Other opportunities for being an assistant at these studios include the positions of first assistant and second assistant, in which you would work for the studio manager and photographer.

USING THE INTERNET

The Internet is another extremely important research tool. You can go onto any of the major search engines, type in keywords such as "commercial photography," and pull up thousands of sites. You can find sites related to your specific geographic location or to locations anywhere in the world. You can see all kinds of Web sites with visually moving work. As a newcomer, this can be one of your first steps toward formulating what appeals to you visually. That knowledge will, in turn, help you determine what you want to photograph. The Internet is also an invaluable tool for working photographers because it allows them to view new techniques and decide in what new directions they would like to take their work. If you are having a hard time deciding exactly what in the wide realm of commercial photography interests you, try deciding the opposite first. Make an ongoing list of the types and styles of photography that you know you don't like. Eventually, you will end up with a sense of what you want to do.

> **Photography assistants gain experience that cannot be duplicated in a classroom or substituted by reading a book.**

JUMPING IN

The old saying that "timing is everything" is trite but true. **There is no better time than today to start mapping out your future.** And there is no better time to plan a career change than when you are already working.

A few simple, preliminary steps will help you begin your journey towards a new profession or a rejuvenated one:

- Commit yourself to the pursuit.

- Decide which resources to pursue so you can acquire the necessary knowledge and get hands-on experience.

- Set achievable goals within realistic time lines.

- Track your practical and mental progress on a weekly or monthly basis.

TIMING IS EVERYTHING
© TREVOR MOORE

Establishing Goals

How does one *really* get started with all of these different tools and resources? That is a loaded question we will address in two parts. First and most importantly, you must decide you are committed to learning about and experiencing all kinds of commercial photography. Secondly, you must set some goals on a time line. If you are going to college, for example, you should decide whether that will be a two- or four-year program. If you are a professional in another field thinking of making a career switch, then ask yourself how long you need to make the transition. Decide how you will make that switch using the resources we've described. It doesn't matter if you end up being slightly off-target with the goals you set up. You can always reevaluate them and your time line. What matters is that you actually set some parameters and goals for yourself. They are required for gaining discipline and working toward a successful transition. As you move further and further into the business realm, you'll understand the importance of establishing and setting goals. If you are a working professional, you still need to determine what it is that you like about your career and what you feel is working. Then you need to evaluate what you want to change or add to it. Sometimes that means raising your prices, but more often it means creating new portfolios and rejuvenating yourself so that your photography is still fun. You'll hear the term "fun" a lot in this book because it is an extremely important concept. A sense of fun in your work environment and your attitude will help you to create strong, original photographs.

The investment you need to make to get started in commercial photography may appear monumental. There is no doubt that photography can be an expensive venture, but just keep in mind that you don't need to run out and buy everything you'll need right away. Always make sure you need a piece of equipment before buying it and make sure you shop around—don't impulse-buy. Invest in your basic needs first, such as cameras and lenses.

Remember, as your career progresses, you can, as needed, rent camera gear, lighting equipment, and other items. If you're a working professional now, you should still initially rent rather than buy a piece of equipment you need for a specific project. By renting, you can determine if you like the equipment and brand and whether you would use it a lot. The rental fee for extra equipment can oftentimes be invoiced to your client. If

It is always difficult to just "jump in" to a big change in your life, but remember, that is what success really takes. You are exploring a powerful visual medium; you need to start paying attention to it! Look at advertisements, photo books, magazines, and movies. Analyze them, be inspired by them, start setting personal goals by them. *It's time to make your move,* whether that means a career change or a change in your attitude. Now is the time to actually do something!

you do have to buy something, you don't necessarily always have to pay full price for it at a retail store. Used equipment can be found in the classified advertisements in newspapers and professional magazines and also on the Internet. If you have questions about what the price ranges are for used equipment, ask around. If you are not sure about the quality or condition of a piece of used equipment, take it to a camera repair shop or a working professional to get a second opinion. Be wary when buying over the Internet. Make sure the Web site you buy from has a policy that allows you to get your money back if the goods are not in the condition you were promised they would be. It's a good idea to use a credit card for such purchases so that your credit card company can help you if there is a problem with the merchandise.

The Art and Technique of Commercial Photography

You'll begin to experience the exciting art and technique of commercial photography if you keep your eyes and mind open and start to formulate ideas about the areas of photography that excite you. As you go through this book, also explore the Internet. See the work of other photographers, reach within yourself, and determine what you like about the images you are seeing. Is it a particular style? Is it the lighting technique? Could it be the images' use of color and composition? Are you more drawn to color or black and white? Maybe photographs of people move and inspire you more than those of products. There are literally scores of categories and specialized fields within commercial photography that are too numerous for one book to cover. I've included a list of several popular categories for you to use to select areas that might interest you.

The purpose of this book is to inform and educate you as well as to inspire a new attitude within you. By discussing some of the larger categories of commercial photography, you'll learn about product illustration and various techniques for lighting, composition, selective focus, gels, fills, and more. However, this book's chief objective is not to dole out technical information and a series of how-to projects, but rather to expose you to a way of seeing by showing you an array of images in several of the categories within the profession. It is not possible to master the art and technique of commercial photography without first expanding your visual sense and your understanding of creative possibilities.

SEASHELL STILL LIFE
© RICK SOUDERS

This photo relies on simple lighting, selective focus, and selective diffusion in front of the lens. The photo was part of a personal fine art project.

POPULAR CATEGORIES OF COMMERCIAL PHOTOGRAPHY

Aerial	Food
Annual Report	Internet/Web
Architecture	Lifestyle
Art/Gallery	Magazine
Beverage	Medical
Black-and-White	Music/Albums
Books/Publications	Nature
Catalog	Personal Growth
Celebrities	Pets/Animals
Children	Photo Manipulation
Corporate	Product
Digital	Scientific
Documentary	Sports
Editorial	Stock
Executive Portraits	Travel
Fashion	Underwater

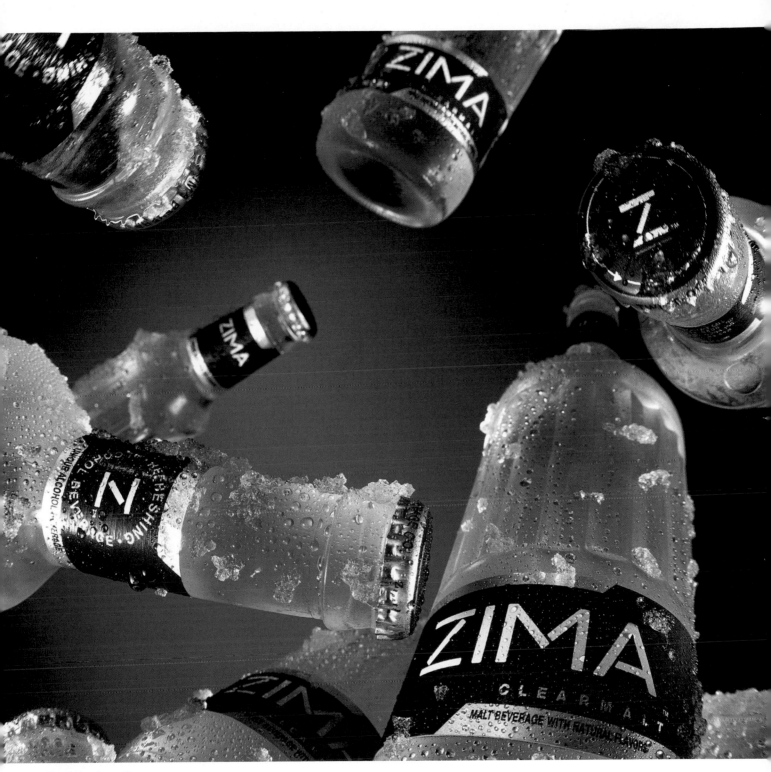

ZIMA WIDE ANGLE BOTTLES
© RICK SOUDERS

This image was taken with a Mamiya 6 x 7 fish-eye lens. The bottles are all suspended about 6 inches apart. No retouching was done to accomplish this effect. A separately lit blue background was placed about six feet behind the bottles.

Product Illustration

What we call "product illustration" covers a huge variety of still-life photographs taken in the studio. You can create a product illustration (basically, a photographic still life), with a stand-alone object, fruit, vegetables, cologne, shoes, books, or just about any object. Product illustration is used in advertisements that appear in the following places and more: magazines, in-store ads or signs, newspapers, billboards, posters, on buses, at bus stops, in subways, the Internet, and in annual reports for companies.

Food photography is a form of product illustration, but the "product" happens to be edible. In the upcoming chapters I'll review basic food lighting techniques and ways to use color, composition, and camera angle to create strong images. The real trick to successful food photography is incorporating "taste appeal" into your images. Whether the shot be of a juicy burger, a skewer of meat cooking over flames, a frosty cold beer, or a mouthwatering piece of chocolate cake, the image needs taste appeal. To accomplish this, a food photographer usually teams up with a talented food stylist. The photographer must also be an excellent communicator because it is his/her job to interpret what the client is trying to convey about their product in the ad and then direct the food stylist to achieve a certain look. The teamwork between photographer and food stylist is critical for achieving success in this particular category of product illustration.

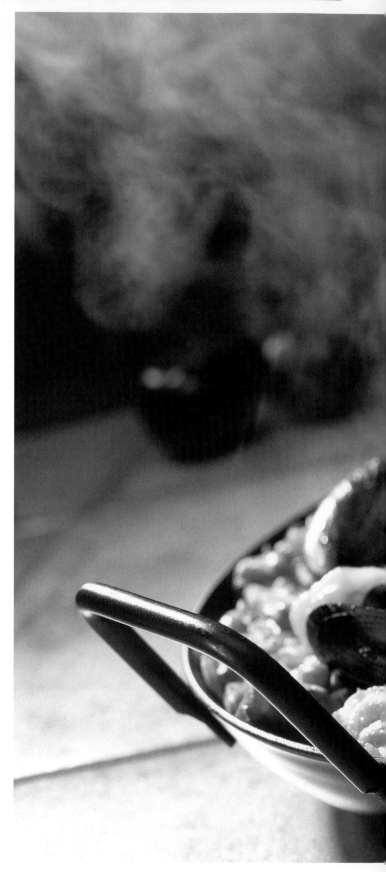

SEAFOOD STEW
© RICK SOUDERS

This image was created for a magazine article and was shot with a 4 x 5 view camera from an unusual angle and using very select focus.

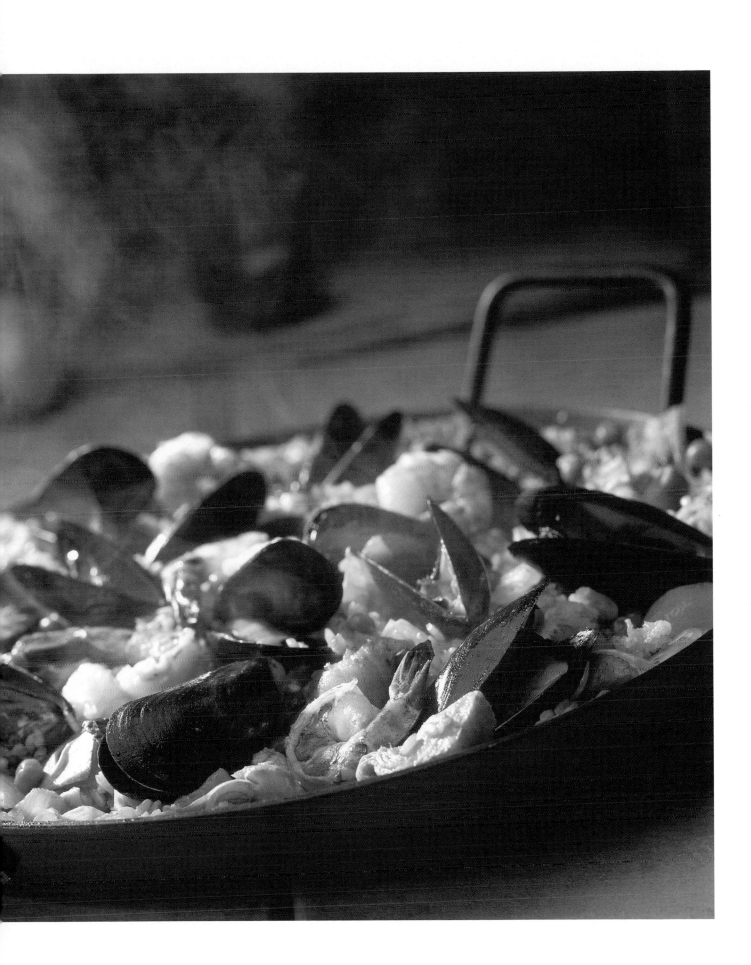

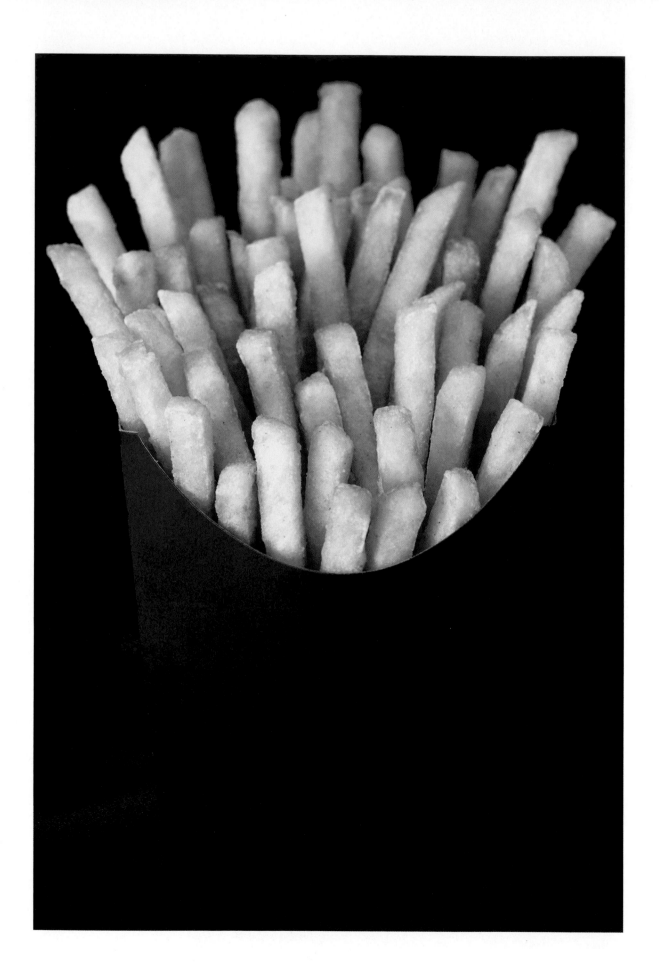

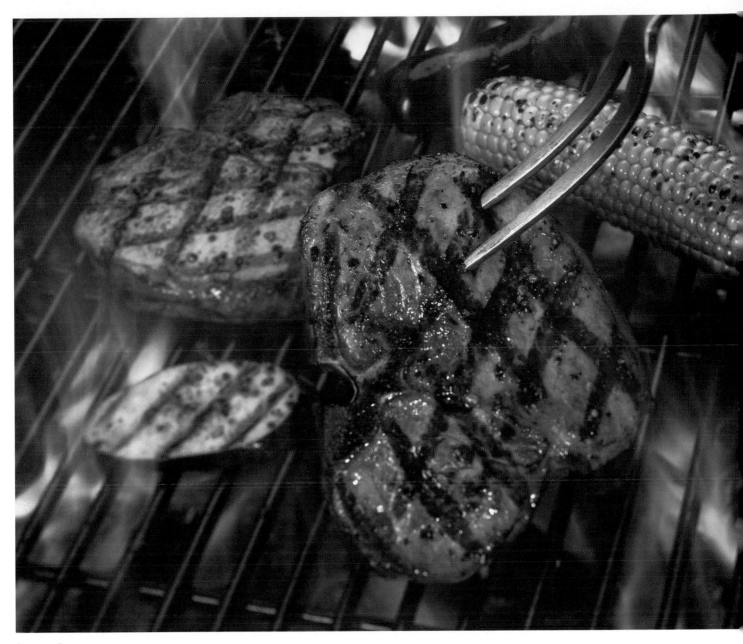

STEAK ON FORK
© RICK SOUDERS

Lifting a steak over live flames is a unique way to liven up a food shot.

BLUE FRIES
© RICK SOUDERS

This photo was both a portfolio piece and part of a direct mail campaign. The idea here was to show a simple, American staple food from a completely different, simple point of view. The simple setup and bright blue background made for a very striking image.

BLUE SKY COLA
© RICK SOUDERS

Beverages can be difficult to shoot.
This image presents the product
from an unexpected point of view.
The soda looks cold and refreshing,
has strong graphic appeal, and
jumps right out at you.

Beverage photography is another category of product illustration.
In many ways, it is similar to food photography; many of the same
techniques apply to it and still-life and food photography. There are,
however, several techniques I will discuss in Chapter Four that are
unique to photographing beverages and liquids, such as lighting.
Keep in mind that some professional photographers specialize in
beverage or liquid photography, and many times these experienced
pros style their own beverages. If you are new to this venture or are
trying it for the first time, you should probably hire a food stylist
with lots of practice styling beverages and liquids.

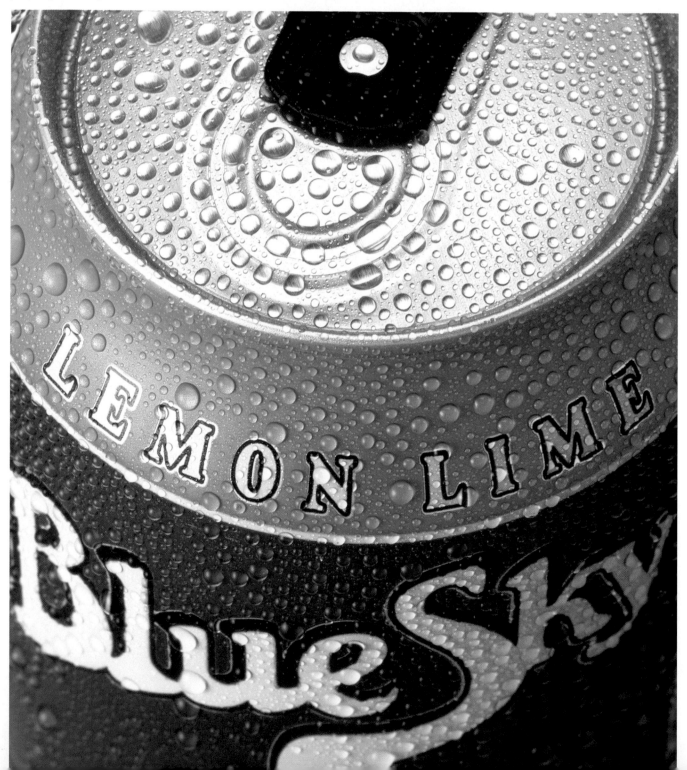

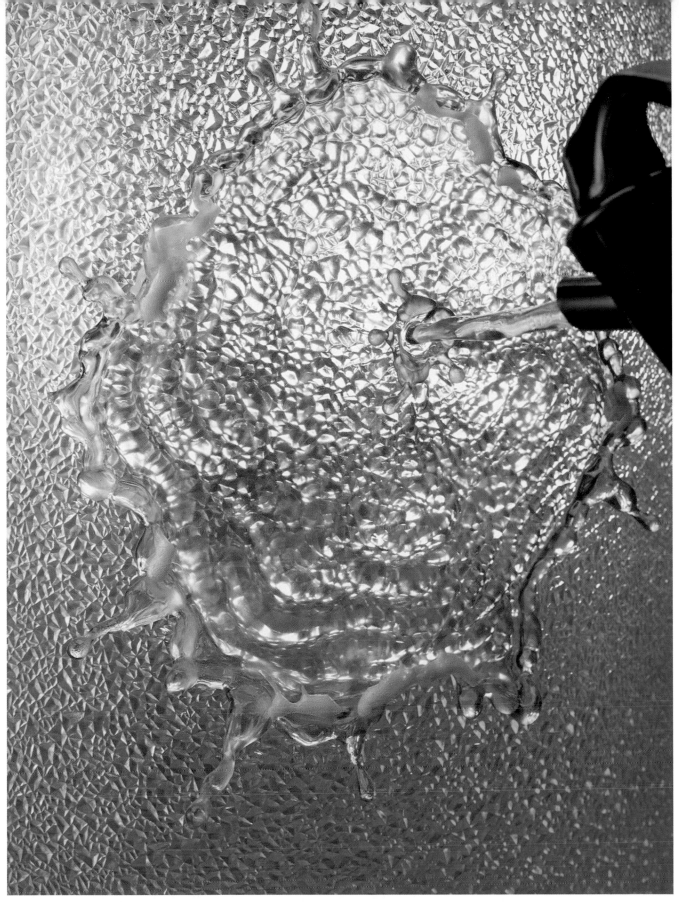

BEER SPLASH
© RICK SOUDERS

There are many ways to shoot common beverages like beer. Try photographing these products for
your clients in unexpected, creative ways to make such familiar images exciting and interesting.

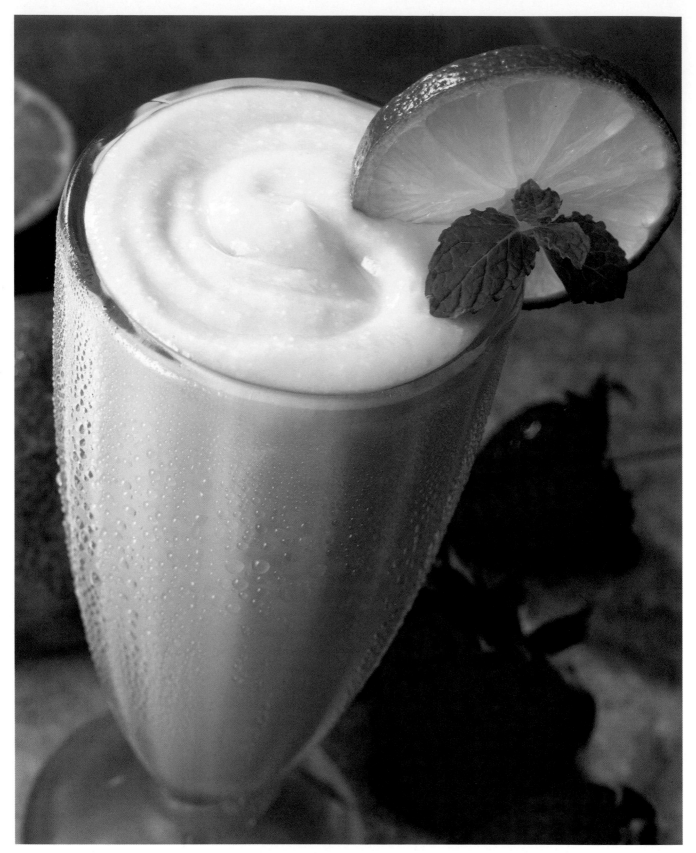

FRUIT SMOOTHIE
© RICK SOUDERS

A cold fruit smoothie shown from an interesting perspective becomes very compelling and
appealing in this photo. Notice the use of select focus and color.

People photography can also fall into the category of product illustration when the images also contain products. However, people photography can take many other forms and cover many categories. In Chapter Five, I will explain the different kinds of people photography and its different uses. I'll take you through a basic fashion portrait, and I'll show you an example of an executive location portrait. I'll also explain how to shoot models on location. Because this category of commerical photography is so broad, Chapter Five will give you an overview rather than an in-depth discussion of some relevant and contemporary techniques and some interesting camera angles demonstrated with vibrant images. When you do people photography, you'll learn the importance of being able to work with and direct personalities. You'll also come to understand the importance of model release forms, examples of which are provided in the chapter. I will discuss finding models, talent, and stylists later on.

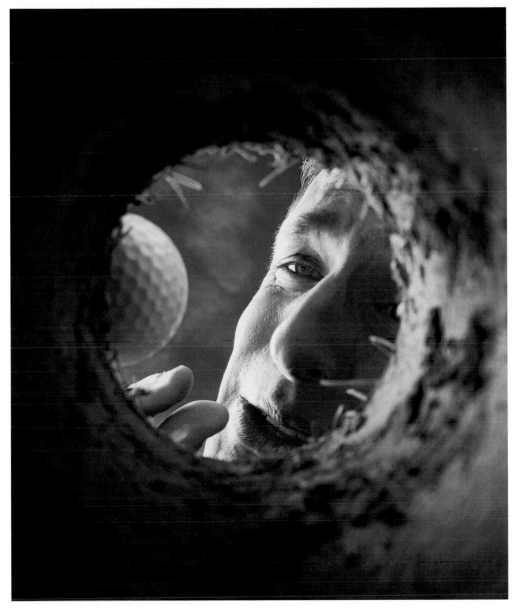

GOLFER
© RICK SOUDERS

Envision your subject from a totally new angle. I wanted to tell this golf "story" from a new point of view. The camera I used was a Mamiya RZ 6 x 7.

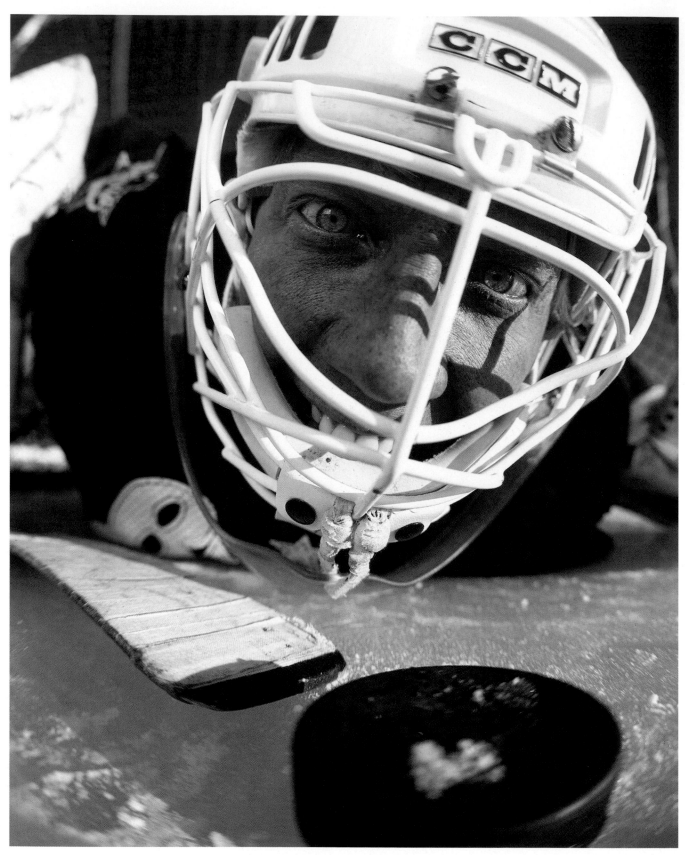

ICE HOCKEY DUDE
© RICK SOUDERS

I used a Mamiya fish-eye lens for this outdoor shot. I put the camera on the ice about 14 inches from the subject. I used a reflective fill card to bounce light into the shadows.

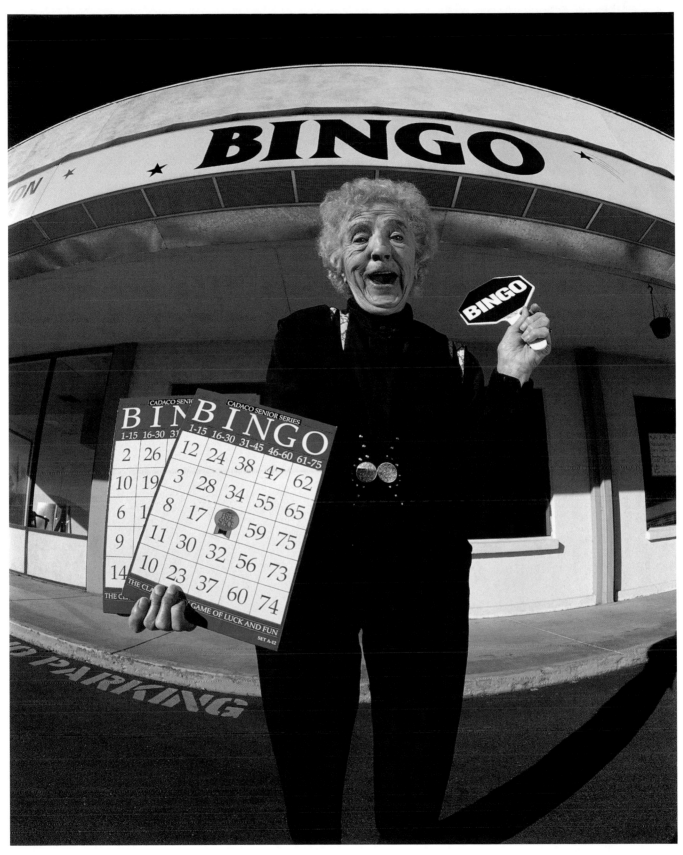

BINGO LADY
© RICK SOUDERS

This image was part of an ongoing personal photo project. Here I used the Mamiya
fish-eye lens and a reflector fill.

The revolution in digital technology has made quite an impact on the photography world. While many photographers are afraid of this highly technical medium, the truth of the matter is that digital photography is here to stay. It will only get more prominent. Think of it as yet another resource in your equipment arsenal. There are appropriate and inappropriate ways to use digital imagery, and a photographer always needs to be a good artist and a good technician. A photographer will always need a sense of "vision" and an understanding of lighting, color, and composition to create. Clearly, we are rapidly becoming a smaller, more connected world through technology, and every day, millions of new visuals are released into the marketplace via the Web. If you look at technological advances as exciting new challenges, you will not only survive the digital jungle but prosper in it. Chapter Six provides a closer look at digital photography.

DIGITAL TOAST
© RICK SOUDERS

I created this image for a client's trade ad using the Mega Vision T2 camera. This image demonstrates the fact that digital captures are much faster than traditional instant print materials.

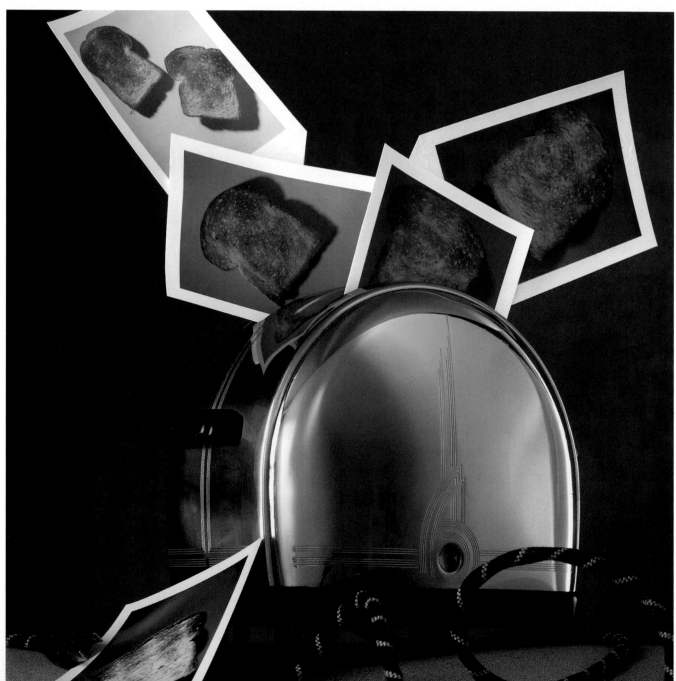

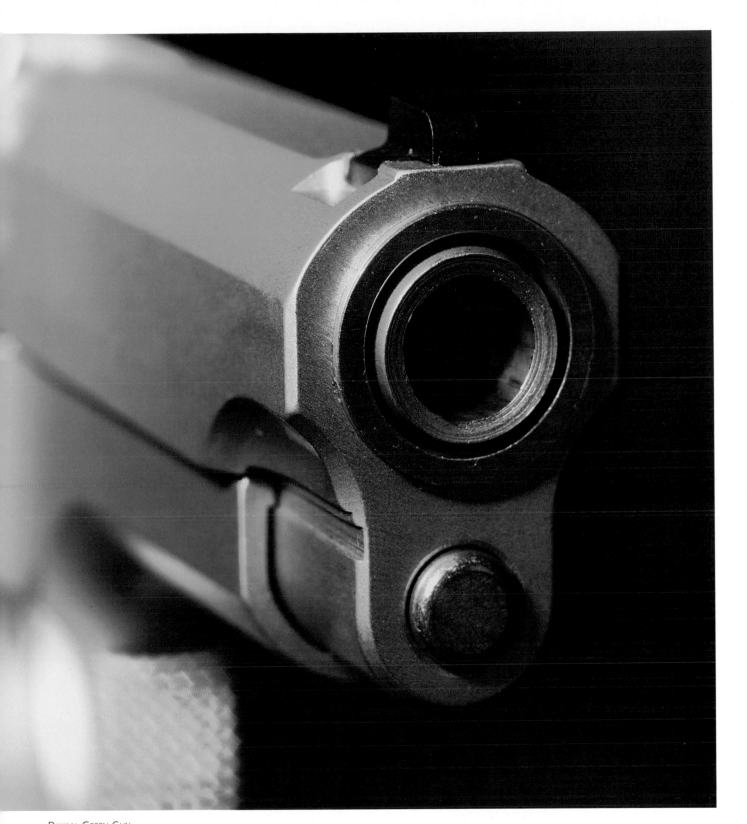

DIGITAL GREEN GUN
© RICK SOUDERS

Here is another example of a way you can use a digital capture, a unique
perspective, and a controversial subject for an effective editorial photograph.

Getting Started

How does someone get started in commercial photography? While that may seem like a simple, straightforward question, it actually requires a lot of thought, soul-searching, and research. People ask me, as a graduate from a four-year college with a bachelor of fine arts degree, if my education played an important role in the formulation of my career and life's goals. The obvious answer to that question is yes. I realize, however, that the college formula is one that worked for me. It might not be right for everyone. To help formulate your plan, let's look at three simple questions.

Where to Begin: Essential Questions

What about photography makes you to want to pursue it as a profession? Don't give a superficial answer to this question and say that you want to become famous like Richard Avedon, Annie Leibovitz, or Mark Selegar, or that you want to become rich. It's possible to achieve these very long-term goals, but those answers are not at the root of this question. Attempt a more personal and cerebral answer. Do you consider yourself a visual person? Do you find images inspiring? When you are hiking on a trail, driving in your car, or walking through a shopping mall, do you just focus on where you are going and what's in front of you, or do you notice the visual elements of your surroundings? Do you see a beautiful silhouette of a deer running across the trail; the way the light filters through the trees; the way your car headlights illuminate the wet pavement during a rainstorm; how the clouds reflect in the glass of a skyscraper; a baby crying in its father's arms; or the way that escalators make surreal forms as they wind their way upwards? This soul-searching question is one that even seasoned professionals should revisit to keep their photographs fresh and their energy levels strong.

What kinds of photography do you appreciate most?
Keep in mind that most of us have several categories that we appreciate; that is perfectly normal. Photography is a huge medium, however, and commercial photography requires you to be aware of your likes and dislikes. Discover what moves you visually and what does not. This is important whether you are a novice with no camera experience or a working professional. You may not know what exact area of commercial photography in which you will finally land, but an awareness of what you like will help to narrow the playing field. You can rule out things in which you simply have no interest. You can also rule out areas about which you have no opinion. If you aren't moved or inspired by a particular kind of photography, move on. You may find several categories that interest you. Write them down, and as your research and your visual vocabulary grow, keep track of how these categories expand or shrink. For example, I have a friend in the profession who likes black-and-white imagery, travel photography, and editorial "slice of life" type photographs that feature people.

These categories, while completely separate, can work together. My friend travels for his career, and along the way he often takes a lot of black-and-white photographs. When he travels, he is able to capture images of people, their lives, and their culture. These different elements mix well for him. He also has a studio and shoots studio imagery to generate income and offset his mix of skills. Some photographers can hone their interests into a single specialized skill such as food photography. If there is one formula that keeps you happy, provides you with ongoing creative and visual challenges, and brings you a comfortable income, then that formula is the perfect photographic "specialty" for you. My studio is unique and leans toward the other end of the spectrum—it specializes in many categories. While going through college, many of my professors said that one must specialize in order to be really successful in photography. I never liked that attitude because I knew in my heart that it wouldn't work for me. It was easier for me to select the kinds of photographs that I didn't want to do than select those kinds that I found interesting. At my studio, I found a unique way to combine my years of experience with my diverse interests in photography. I shoot food and beverage photographs, which include those of splashes and liquids in motion. I also shoot people and lifestyle photography. How do these elements work together for me? I like working in the studio, and I enjoy the challenge of still-life work. One of my first jobs out of college, besides being a studio manager for a well-known Colorado photographer, was working for the Coors Brewing Company Creative Services Department, where I learned a lot about beverage and liquid photography, which then became quite a fun and challenging mix for me. Because I am a people-oriented person, I wanted more of people photography in my portfolio. They were not too difficult to incorporate because most of my food and beverage clients advertise their products in real life or "lifestyle" settings. I was able to shoot a lot of both people and products. This soon expanded to annual report coverage for the same clients. The mixture of people and product was the ideal way to keep my world constantly challenging, changing, and therefore interesting on a day-to-day basis. Researching and discovering what you like will help you move toward really getting started.

PORTFOLIO IMAGE
© TREVOR MOORE

How do training and education fit into your life and your career goals, and how can you find a way to pursue either? Determine your level of skill in and your ability to communicate ideas visually. It doesn't matter whether you are a first-time camera operator or someone already in the profession. The goal of this question is to determine where you are at this point in your life, where you want to go, and how to set goals to get there. As I mentioned before, if you are at a point in your life where you have the time, patience, and money for college, there are several outstanding two- and four-year programs that are well worth your while. I received a two-year degree in photography myself and a BFA with honors from the Art Center College of Design in Pasadena, California. I also attended Brooks Institute in Santa Barbara, California. If you decide to enroll in a college or pursue a formal education in photography, you should research your choices carefully. Remember to base your research on where you are personally, financially, and emotionally. Maybe you have some experience in the arts, design, or photography and you need a shorter term jump-start into the photography profession. In this case, a good solid junior college or two-year program is an excellent choice and usually a less expensive one. If you are young, graduating from high school or junior college, or have decided that you want to explore commercial photography, then you may very well decide to pursue a four-year college degree. Keep in mind that if a four-year program or specialized program is for you, there are scores of options for financing tuition. Maybe you were already in photo or design school and took a break and now want to get reimmersed. You can go back to school full-time, or you can take night or weekend classes that will fit into your schedule. Don't rule out related classes such as small business management or computer courses on programs such as Microsoft Word, Works, or Excel. Photo manipulation courses such as Adobe PhotoShop are also important to consider. I will address the overwhelming relevance of these related business topics in Chapter Eight. As I have pointed out, if you are not interested in classroom experience and are at a point where you can take advantage of assisting in a professional studio, do so. It could prove to be one of the most awesome learning experiences you will ever have. Keep in mind that you can assist while you are a college student and that some of your instructors may even hire you to assist with their photographic assignments.

Assisting is an invaluable experience because you not only get to work in a real-life commercial photography environment, but you also get to work with a professional photographer and learn all of the things that go into a successful photography operation. You might be helping set up lights, running film to a lab, getting props, building a set, or running other errands. No matter what your task is, you get quickly immersed in photography's business realm. You get to see art director's layouts and how the photographer interacts with clients and art directors. You'll witness firsthand on-set problem solving, and you'll experience (with luck) some great lighting techniques. All in all, it's a wonderful learning environment, especially when you consider that you are being paid to be a part of this team. The flip side to this assisting experience is just as valuable, and believe me you'll experience it sooner rather than later. You will inevitably assist someone you may not like or respect for a number of reasons. You may find the following advice hard to believe now, but you'll understand it later: cherish these negative experiences because they will be your best lessons in skill-building and character-building. Think about it. You will see the way that some people don't treat everyone as a valued part of their team. You'll see personalities get in the way of business. You'll work with photographers who forget they are really "vendors" and that the client or advertising agency is the one footing their photography bill. You'll see some photographers fold under pressure and do mediocre work. These lessons are so critical to your success that you won't even realize it until you find yourself in these situations later. Then you'll reflect back and remember how important it is to treat everyone as an integral part of your team. Rely on your team to help you through stressful situations. Treat your client as a *client*. Separate your personal feelings from your professional capabilities.

One final option we haven't discussed in your quest for your starting point is the option of a student internship. They are the perfect combination of formal education and assisting. I applaud colleges that support student intern programs with the businesses in their communities. My studio supports two intern programs, one with my old college, Colorado Mountain College, and one with the Colorado Art Institute in Denver. All of my student interns are still working or studying in the photography profession which is, I think, a testament to the value of internships. I feel that the interns I worked

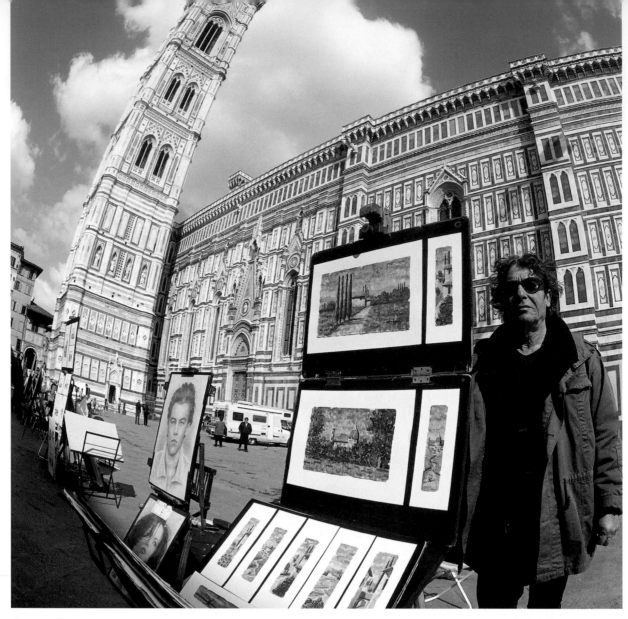

ARTISAN IN FLORENCE
©RICK SOUDERS

This shot of a local artisan was taken on location in Florence, Italy using a Mamiya fish-eye lens.

SOUDERS GEAR BOX

35mm Camera Systems
(1) Nikon F-100
(1) Nikon F-3
(7) Various Nikon Lenses

Medium Format Camera
(3) Mamiya RZ 67 Pro
(9) Mamiya Lenses

4x5 Camera Systems
(4) Calumet and Cambo Systems
(12) Schneider & Nikkor Lenses

Digital Camera System
MegaVision

Lighting Equipment
Speedotron Packs & Heads
Broncolor Pulso Packs & Heads
Chimera Light Banks
Light Brush Light Painting Device

Tripods & Heads
(4) Gitzo & Majestic

Accessories
Various Umbrellas
Various Flexible Reflectors
Multiple C Stands
Bogen Arms

with really jump-started their real-life experience in this business. Determining how training and education will help you deserves some serious attention. Research your options and jot down your short- and medium-term goals.

All three of the questions I've asked in this section may seem rudimentary, but they can really help you formulate a plan, or at the very least, a short-term goal until you can reevaluate your bigger plans. Remember, as you grow and learn, it is important to continually evaluate your interests and skill level. Contact schools and working professionals to whom you can direct questions. Doing so will help you answer all three of these basic questions.

Essential Equipment

Let's skip a step and assume that you are now at the point where you are ready to set up shop. This is a big step, no doubt about it. While you are in school, studying or assisting, start collecting some of the photography gear that you will need later. This is a medium-term goal. You will need obvious first purchases. As you progress through your transition from student or assistant to professional, you'll need things like a 35mm camera system and a selection of lenses. You'll need a tripod. At some point you'll want to start selecting lighting equipment and accessories. Depending upon your goals and needs, you may want to get a medium-format and a large-format camera to add to your arsenal of equipment. This will be the most expensive and time-consuming part of your endeavor, but don't panic.

Unless you are independently wealthy (and congratulations if that is the case), you should pace your purchases, learn as much as you can learn, earn as much as you can earn, and never get overly impatient about where you are currently. To lean on an old cliché, "Rome was not built in a day." An important message in that cliché is that Rome is still standing today. Take the necessary time to set yourself up for success and be determined to learn along the way. Patience is very important when starting or changing your career, especially in commercial photography. Always be open-minded and learn while opportunities present themselves, no matter how far along your photography career has progressed.

Let's get back to the setting up of shop and getting started. There are several ways in this digital millennium to search for equipment. First, immerse yourself in the profession. Go to local photography meetings and events. Get to know the photographers you respect. Start networking with labs and professional vendors. This step is never premature because you can only continue to benefit from the relationships you make. These same contacts may extend you special deals on photography equipment and accessories. With the exception of my 35mm camera and my medium-format system, I did not buy one single piece of brand-new equipment until I was well into my career.

Remember, no one cares about your equipment—they only care about the images you can produce with it.

You can also do an incredible amount of research on the Internet. You can find scores of sites that sell equipment online. My studio manager has purchased equipment online and sold some of my old equipment that way as well. If you buy online, make sure you do so through a reputable Web site. Remember to do your research before buying from the Internet and protect yourself from making a bad purchase.

In preparation for this book, I compiled a list of the types and brands of equipment I own. I call the list Souders Gear Box, and it represents the majority of lighting and photography gear and accessories that I use (see p. 38). While I like and support the equipment I use, there are several reputable companies in each category, and you should investigate prices and quality differences on your own. Specific recommendations or suggestions for equipment are outside the realm and intent of this book; each photographer has to find the equipment that best suits his/her preferences.

Studio Space

The kind of work space you need depends on your budget and the kind of photography you do. I think you should, at the very least, have access to a studio.

Those photographers who do not own studios, but who perhaps rent one or use the space a client provides, shoot many of their images on location. Examples of those would include photographers who do a lot of outdoor editorial, location, and product or people assignments. Travel and stock photography and magazine editorial features are oftentimes shot on location. (By

location, I mean anyplace outside your normal studio space. Traveling to another city to shoot, or even just shooting inside a corporate office building, are both considered "on location" assignments.)

Photographers who shoot exclusively "in-studio" do not ever go on location. These are mostly product photographers, catalog photographers, food photographers, or those who do advertising illustration.

The large majority of photographers shoot both on location and in the studio. If you are in this category, there are two ways to approach your workspace:

1. You can own or rent your own studio. That way you have access to it any time you need to shoot.

2. You can share or co-op a studio with other photographers. The advantages of sharing a space are that you can share the rent, utilities, and other maintenance costs. The disadvantage is that you have to schedule your studio time around your studio partners' time. You also need to be sure that your partners are honest, reliable people who won't solicit your clients and who will respect your equipment and keep the studio clean.

FARMERS' MARKET
© RICK SOUDERS

I captured the vibrant colors and textures of this woman's fresh flowers and seasonal vegetables at a farmers' market in Salzburg, Austria.

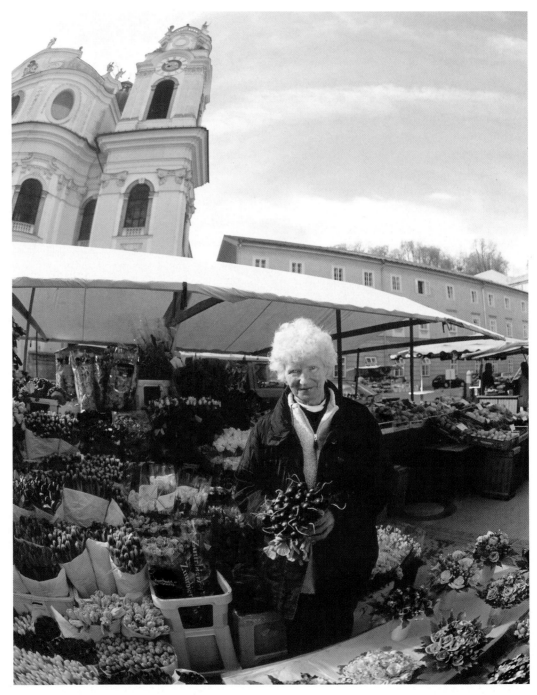

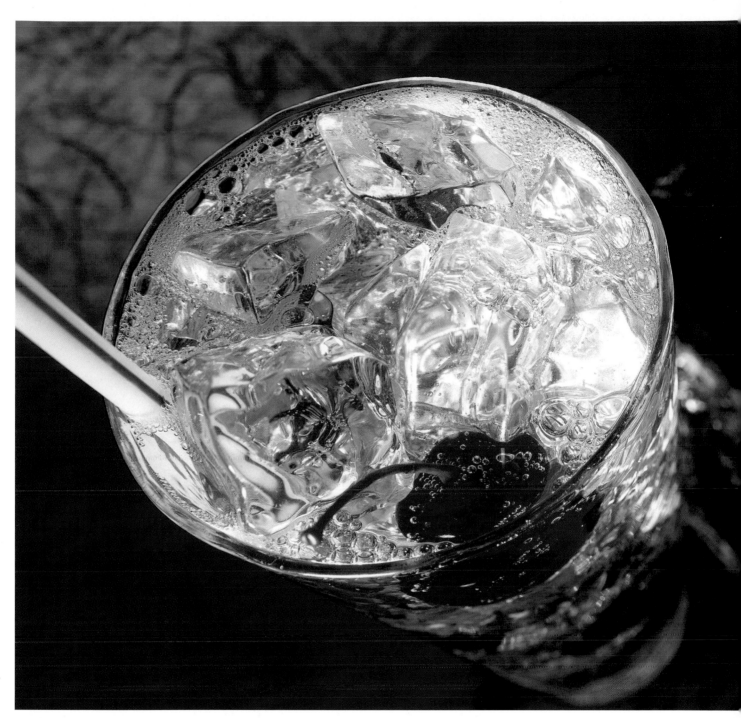

It is best to use rental studios until you get a feel for how much of your work will be in studio versus on location. There is no right or wrong way to get started in terms of studio space. Just remember that you should keep wherever you shoot as clean and professional as possible. I once visited a friend while he was shooting for a client. He was renting space at a studio in which his partner also lived. While he was shooting, the live-in artist was rattling around in the attached kitchen making (burning) breakfast. The client was not impressed, nor was I.

Setting Up the Business

Getting the proper business tools in place is as essential as your ability to create an image, maybe even more so. There are basic tools you need to have available for prospective clients. We will discuss most of these in depth in Chapter Eight, but for now suffice it to say that sometimes the first impressions you make may be the last. What follows is a list of the essential elements you'll need for making that first impression a good one. I call it the "Business Gear Box."

These ten items are essential for getting started in the advertising and business aspects of the profession. The importance of each item follows in brief, simple terms.

ADVERTISING ESSENTIALS

Business Cards

Business cards are a must, no questions asked, period! The card should list a legitimate phone number, either that of your regular phone line with answering machine or your cell phone. The card should also list a fax number, either that of your own fax machine or that of a number that emails a fax to your computer. Your card must provide a legitimate mailing address. A business card gives you credibility. It also it gives the client a way to contact you again. Cards can be professionally designed or made simply and cheaply. Your budget will dictate this. For now, either choice will work.

Portfolio

You need a professional way to show your work. Besides the way you present yourself in person, your portfolio is the single most important statement you make about who you are. Make the portfolio consistent. If you have transparencies, put them in nice mounts. If you have prints, think about putting them in a nice print book. If you have a combination of transparencies and prints,

show a nice balance, keep everything consistent within the groupings in terms of size and presentation, and have a reason for showing both. **Only show your best work!** When you are not sure if something is strong enough for your portfolio, remember, less is more. We'll talk more about portfolios in Chapter Eight.

Résumé

You need a résumé when you are beginning your career. It gives photographers and potential clients more information about you, although they are more important for seeking work with other photographers than for getting clients. Eventually, you won't need to present yourself with one. Then you'll know that you've moved up to the next rung on the ladder of success.

Promotional Pieces

You need a simple, inexpensive.promotional piece to go with you and your portfolio. Many photographers now produce them on their inkjet printers. You can create a simple 4 x 6 or 5 x 7 card. Postcards are an affordable option, and there are several companies out there that will print 500 of them for you for less than $200. Don't get me wrong: you can spend as much as you like, but some of my favorites have been one-of-a kind pieces that were produced for a couple of bucks plus postage. A promotional piece is one more important way to demonstrate your professionalism, and it gives clients one of your images to keep. You can use promos as leave-behinds when you show your portfolio, or you can mail them to clients about three weeks after your meeting to remind them of your work.

Thank-You Cards

Thank-you cards are important for two reasons. They are a courteous touch in this fast-paced, harsh business environment. Saying thank you for looking at my book or awarding me a job is another way to call attention to yourself as a professional. Thank-you cards are a simple but often overlooked advertising mechanism.

BUSINESS ESSENTIALS

Estimating Form

You will need a form that estimates the cost of doing a job for a client. This form can be generated in database programs like Microsoft Word, Works, or Excel. Set up a template so you can use the form over and over again easily. Estimating forms should list all the estimated costs of doing business, such as those for usage, your fee, film, supplies, backdrops, props, stylists, travel, mileage, models, and couriers.

BUSINESS GEAR BOX

What you need to get started!

Advertising Essentials	Business Essentials
Portfolio	Delivery Memo
Résumé	Terms & Conditions
Promo Piece	Releases
Thank you Cards	Estimating Forms

Invoicing Forms

This form can be created using the same programs as the estimating form. Invoicing forms assign a client's billing address, invoice number, current date, and a breakdown of the charges in categories. Some clients may require this breakdown before they can provide you with your payment for a job.

Delivery Memo

This is a standard form that lists everything you have delivered to a client in terms of a portfolio or images. It is a responsible accounting mechanism for the client receiving the images, and it has a clause letting the recipient know that they are responsible for the return of all the images they receive.

Terms and Conditions

Every photographer needs to develop his or her terms and conditions for doing business. "Terms" establish things such as copyright, terms of payment, consequences of cancellations, and other important legal provisions. A sample terms and conditions form is included in Chapter Seven.

Releases

Model and property releases are essential. They give you permission to use someone's picture or property in the commercial advertising realm. Not using these forms can involve a photographer in a costly lawsuit.

Although business matters are discussed in more detail in later chapters, the "Business Gear Box" gives you a general idea of what you'll need to start out.

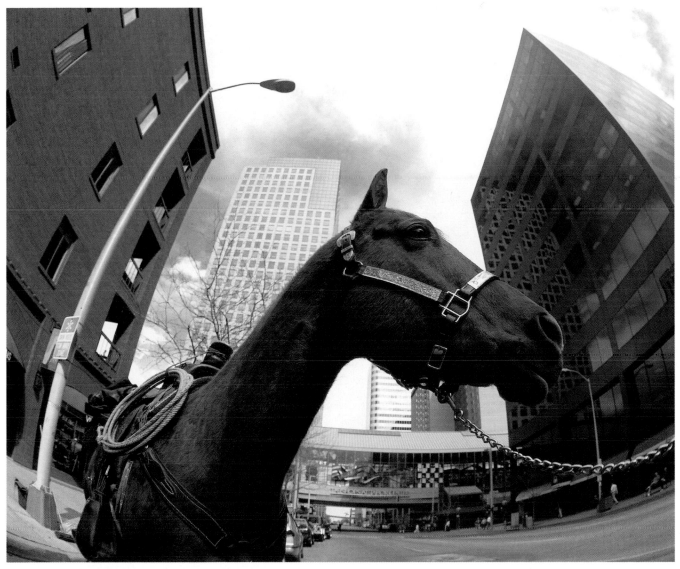

HORSE IN DOWNTOWN DENVER
© RICK SOUDERS

I selected the location and subject of this shot for use in a commercial assignment, but I wound up getting this great stock image while I waited for the first shot to be set up.

The Art of Product Illustration

The intent of this and the following five chapters is not to give you step-by-step formulas illustrating exactly how to produce a specific image, lighting style, or technique, but rather, and more importantly, to expose you to the entire visual process. Many of the topics in the next few chapters overlap each other in terms of their practical applications. For example, many of the same lighting techniques can be used for still-life, product, and food-and-beverage photography.

The realm of product illustration can encompass a vast array of subject matter, anything from perfume to tennis shoes to a still life of fruit to a photo illustration of a toy. Understanding how to use simple softbox lighting as well as scrims and diffusers is essential to product illustration. Knowing ways to use selective focus, colored gels, and reflectors and techniques for shooting on glass will also strengthen your work in this category.

Simple Softbox Lighting

There are many brands of strobe lighting equipment. Do your own comparisons of price, performance, and quality. You can generally get adapters for most strobe light heads so that they will fit softboxes. A softbox is a light-channeling device that fits over a frame or an attachment that hooks to the strobe light head. Softboxes are made of cloth or fabric on all four sides with a translucent white cloth material over the front. If you are unfamiliar with this equipment, stop into any professional photography supply store to familiarize yourself with it.

There are two ways to use a softbox to light your subject matter. You can use it as your primary light source (the brightest or most noticeable source) and thus control the direction from which light is coming. You can also use a softbox as a secondary light source (a less powerful light than your primary source) to create highlights and open up dark shadow areas. Many times professionals will use more than one softbox to light a scene. For example, a medium-sized softbox (roughly 30 x 30 inches) can be placed off to the left or right side of your subject to create a primary light source, which then creates directional lighting and highlights. A secondary softbox (usually adjusted to a lower power setting) can be used on the opposite side to "fill" or open up dark shadows and reduce the highlight-to-shadow contrast ratio. Fill cards can also be used instead of a strobe light source to achieve similar effects (see page 54).

A softbox can also be used over and slightly behind the subject. This illuminates the subject and causes the shadows it creates to fall forward. Again, you might want to use a softbox off to the left or right of the camera as your primary light source and the "top" softbox as a secondary source to create soft highlights and open up shadows. The diagrams that accompany these photographs will give you a general sense of how light placement can work.

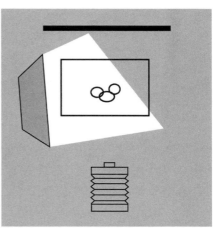

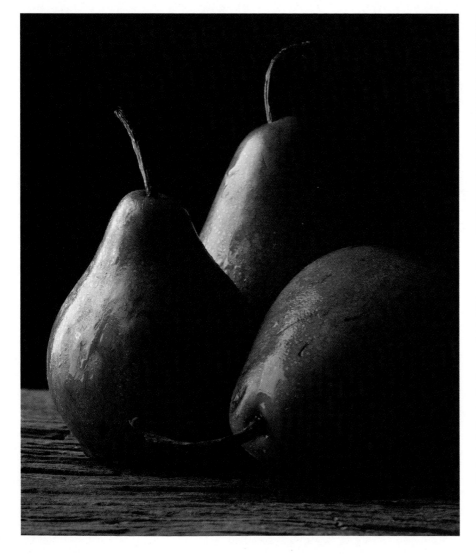

◄ THREE PEARS
© RICK SOUDERS

The first lighting illustration shows three pears sitting on a piece of wood from an old barn. To light the scene, I placed one medium softbox to the left of the subject with no fill cards or background lights.

► CORNISH GAME HEN
© RICK SOUDERS

This simple still life was created using a stone surface, a small wall panel with a window, and a combination of strobe and tungsten lighting. The tungsten light was diffused, and warm gels imparted the inviting look of natural light.

Lighting with Scrims and Diffusers

A scrim is a flat light diffusion panel that resembles a large picture frame. You can make your own scrims with diffusion materials that you can buy in rolls at photo supply and art stores. I adhere diffusion material to both sides of one-inch deep frames so that there is a double thickness with air in the middle. You position a scrim between your light source and your subject matter.

A diffuser is a material that is placed directly on a strobe light's reflector so that the light coming from the strobe head becomes softened. Use a diffuser if you want a more directional light source or a more "harsh" source of light than a softbox might provide.

A scrim, or diffusion panel, works in much the same way that a softbox does but with a couple of very distinct advantages. A softbox is mounted to your strobe light, and the distance from the strobe light to the softbox is fixed. Positioning of the strobe light within the softbox is

therefore also always fixed. With a scrim, the distance between the strobe head and the scrim can be changed. The strobe source can also be positioned anywhere behind the scrim instead of having to remain in a fixed position. The scrim allows you to move the light source closer to or farther away from the scrim, thus allowing you to make the source more or less directional. You also have the option of angling the strobe light through the scrim so that the light falls off proportionally as it travels through the scrim to the subject. I refer to this as light feathering. You can mix scrims with softbox lighting techniques or use scrims to replace softboxes. Experiment to see the differences between various light sources. Keep in mind as you look at these photographs and read about the lighting techniques used to make them that there are several other ways to use light that will give you different effects. That is the beauty of working in a field that allows you to be creative visually.

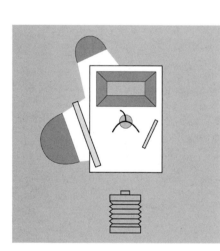

SEAFOOD ON FORKS
© RICK SOUDERS

I placed the three forks on brushed stainless steel and used select focus. To give an overall base exposure, I used a medium softbox over the set on a lower power setting. The scrimmed strobe head off to the left was on 1200 watts/second (w/s), and the strobe with reflector at back left was on 1200 w/s to help create highlight and dimension in the shot.

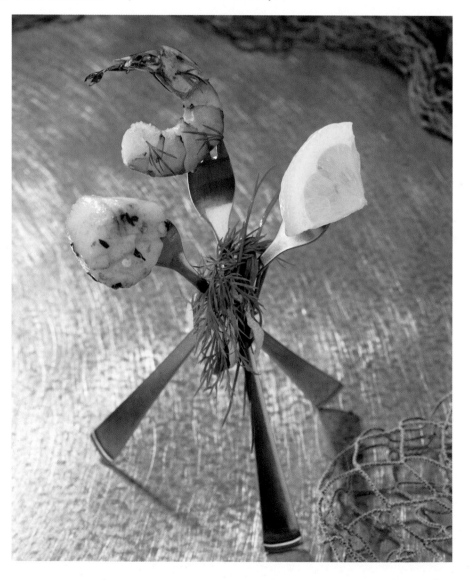

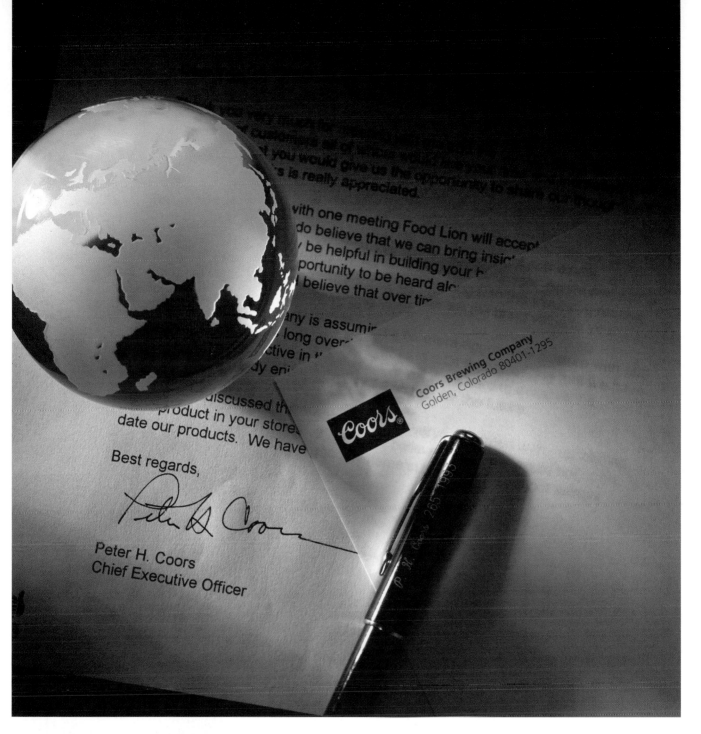

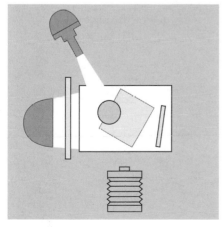

GLOBE AND STATIONARY
© RICK SOUDERS

The camera is positioned so that it looks slightly down onto the set here. A scrimmed strobe head with large reflector is the main light source. I placed a snooted strobe head next to the scrim that is pumping light through the globe, and I put a gold fill card to the subject's right.

Selective Focus and Depth of Field

The art of seeing involves viewing things in varying degrees of focus. Photography students must learn about different camera functions, apertures, and methods of exposing images to get them perfectly sharp from corner to corner. A perfectly crisp, sharp image is imperative for client packaging and art reproduction. However, selective focus and depth of field are imperative in many other contexts. You need to have the ability to simply look through your camera lens and decide which portions of your subject matter will be sharp and which won't. Selective focus and depth of field are great techniques for putting emphasis on a certain part of your subject. They give you the ability to blend colors as they move out of focus. For example, say you are photographing a coffee cup on a table with a newspaper and other props. It makes for a much more interesting image if the foreground is not sharp, a portion of the coffee cup is sharp, and the newspaper and the rest of the table scene are very out of focus. If you plan your shot visually, these effects are easy to achieve. You can use a very shallow

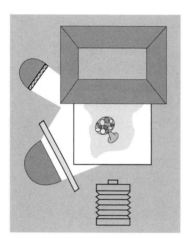

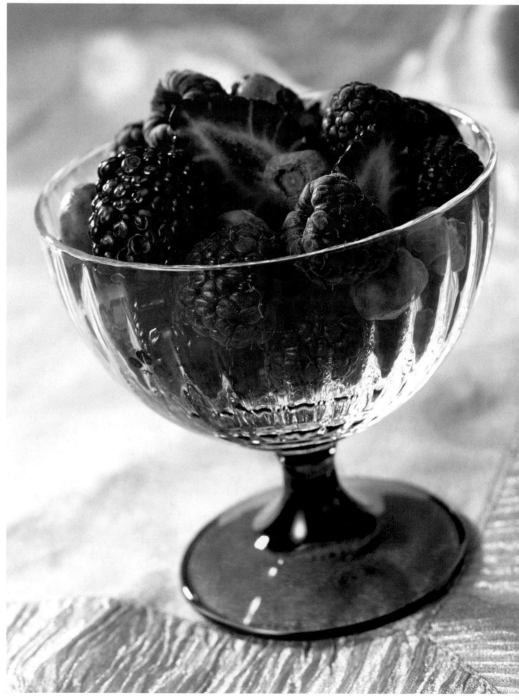

DISH OF BERRIES
© RICK SOUDERS

The shot of a dish of berries demonstrates very select focus. Also notice the way the different colors contribute to the effect of the photo. I positioned the camera slightly above the subject, and put a medium softbox overhead for a base illumination. I put a scrimmed strobe reflector to the left and toward the camera. A reflector with insert is behind the set and to the left, positioned lower to act as a skim light across the gold area.

depth of field, a wide-open lens aperture, or, with large format cameras, you can swing or tilt the lens or film plane from left to right or up or down to achieve particular effects.

Selective focus can draw the viewer's attention into an image quickly and is often used for photographs advertising lifestyle products or food. When it is done well, selective focus imagery can be far more evocative than traditionally sharp images of the same subject. Experiment with this technique and see its results for yourself.

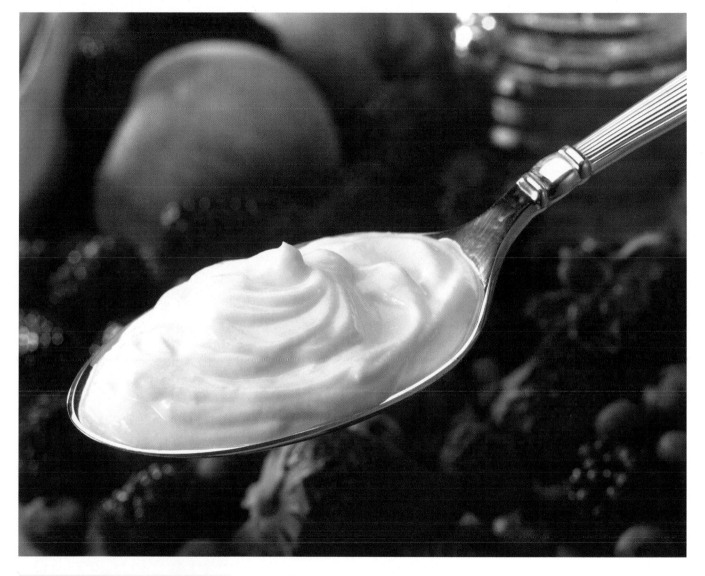

SPOONFUL OF YOGURT
© RICK SOUDERS

This close-up of a spoonful of yogurt demonstrates select focus and depth of field. The fruit in the background is blurred. An overhead medium softbox positioned above and behind the subject gives a base illumination. I also placed the strobe with a reflector and insert behind and to the left of the subject and put a gold fill card to the right of the camera.

Colored Gels and Surfaces

This book's emphasis is on getting you to experiment to stimulate your visual sense. You will not be taught "how-to" specifically and scientifically light every single image that you see here. The goal is to show you different lighting ideas, different points of view, different ways to use color and composition, and to get you to start seeing your world much differently. Notice the color, composition, and graphic appeal of the photographs you see in this book. Also look at their lighting styles, the focus, and the camera angles from which the shots were taken. Each chapter in this book contains information that applies to each and every photograph in the book, so as you continue to learn, flip back to previous chapters and look at the images again. Look for different techniques or qualities that are present in the same image. If you do this, you will have already begun to expand your visual world.

Colored light sources (gels) are important parts of your learning process, along with surfaces or backgrounds. People oftentimes get too caught up in trying to light a product just to make it look good. You can go one step further and make it look different. Of course, you also want the lighting to be incredibly good, and the more you shoot, the better and more refined your lighting style will become. Using gels and backgrounds will also help to expand your visual repertoire.

By adding a little or a lot of color to a scene with a gel or a prop, you can enhance your subject's color and shape and influence your photograph's composition. You can buy gels through photography supply houses or theatrical supply houses. You can also create your own gels with various translucent materials. For example, say your subject is a vase filled with flowers against a textured wall. You could put a "warm" colored gel, such as a yellow,

HIGH PROTEIN FOODS IN BLUE
© RICK SOUDERS

This photo shows the results of a using a secondary light source that has been gelled to add color to shadowy areas. I put a primary light to the left of the set and a large strobe reflector with a blue gel on a lower power setting to fill the shadows. I took this shot for a magazine article about high-protein foods.

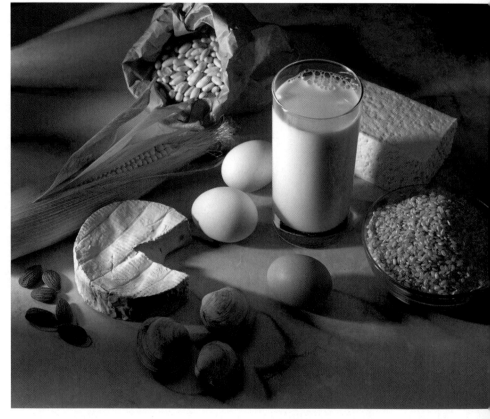

orange, or red one, over your light source to give the feeling of early morning sunlight streaming through a window. A metallic object can also introduce some color to a scene. You can put a blue gel over a strobe head positioned above and behind the subject to create a blue "rim" of light or a wrap-around effect for added impact. Using gels is as easy as placing one over your light source to see if you like the effect. Keep in mind, though, that with gels, a little goes a long way. Don't over-gel unless you intend to. Experiment with different ways of arranging your subject with other colored objects.

Don't be afraid to experiment with backgrounds and surfaces for your product illustration shots. There will be times when you are asked to shoot a product on a seamless white paper background. Clients request this so that their product can be stripped into other ads or used on the Internet. Use every opportunity you have, therefore, to

make your other product shots exciting. Look at the textures, colors, and the reflectivity of various surfaces you could use as backgrounds to shoot your subjects against. Your local hardware store can be a great resource for ideas. Look for tiles, unusual metals, rusty metals, stone, marble, old wood, fabrics, pipes, paints, stucco, wire, and so on and so forth. You can even mix surfaces such as torn paper and stone. Put pastels over sandstone. Put water on shiny metal. The background you choose can make or break your image. Place no limits on your imagination.

If your photograph requires a background, open your eyes. Look at old brick walls, old barn wood, stucco walls, window-blind shadows streaking across a wall, and glass blocks illuminated from behind. As you start to look around you every day, you will be overwhelmed by all of the fascinating backgrounds and surfaces you can incorporate into your photographs.

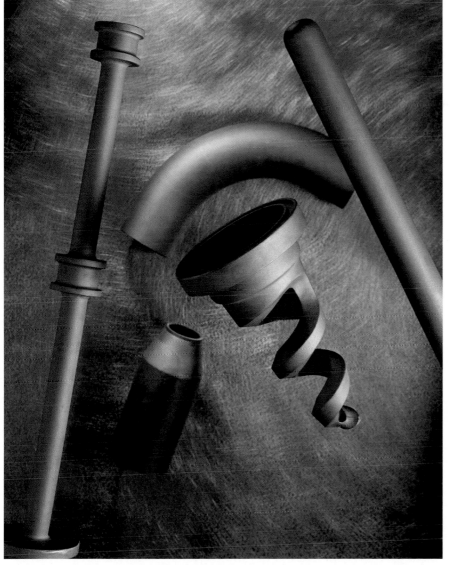

CERAMIC PURPLE TUBES
© RICK SOUDERS

This still life utilizes a two-layer set, with the camera positioned above it, shooting straight down. I used a medium softbox toward the top of the camera. A sheet of glass is positioned about 14 inches above the metallic surface. I placed two of the objects on the metal surface and the other three on the glass. I positioned a large reflector with a purple gel at the top of the set, thus skimming light across the metal surface. I also positioned a large scrim with a strobe and reflector to the left of the camera.

Reflectors and Fills

Reflectors and fill cards are added weapons in your lighting arsenal. A reflector, or fill, reflects light into your scene. Sometimes when you are using a primary light source, you may get some dark shadow areas you want to fill in. Placing a white card opposite the light source reflects light back into the scene and reduces those shadows (in effect, lessens the contrast ratio). You can adjust how much fill, or reflected light, you want by adjusting the size of the card and its distance from the subject.

You can be creative and selective with fill reflectors. You can use a dull or shiny silver card instead of a white one. You can use a gold card if you want to warm up a shadow area. You can use small mirrors to light small areas or create highlights. We discussed using gels and introducing color to a shot; this is another way to do that. You can use colored cards, shiny or dull, depending on the effect you want. Experiment and have fun.

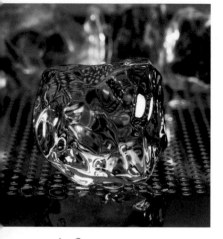

ICE CUBE
© RICK SOUDERS

Here is yet another example of ways you can use surfaces creatively in product illustrations. This ice cube is sitting on a stainless steel rack taken off a telephone cart. I placed the rack over clear Plexiglas and a blue gel was used to illuminate the holes.

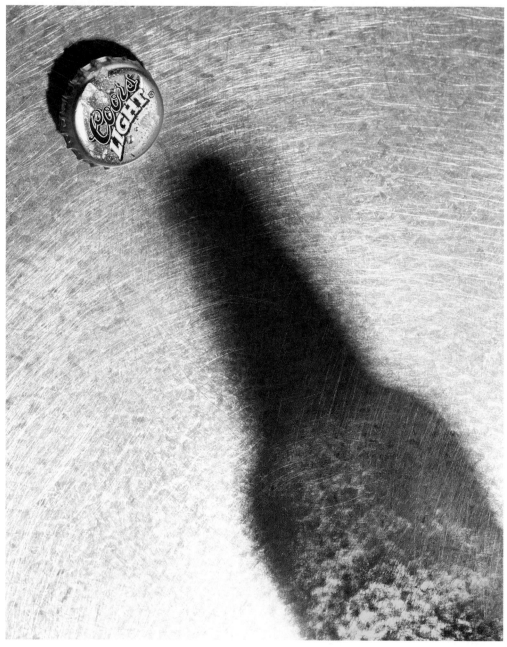

COORS LIGHT SHADOW
© RICK SOUDERS

This is an example of the way background or surface can become the primary focus of a photograph. Here, a beer bottle casts an amber shadow onto the set. The bottle cap above the shadow adds extra visual appeal.

Reflective and fill cards are also used for subtractive lighting—taking away or removing light from a scene. You can do this by putting a card between your light source and your subject to create a shadow or to "flag" or block light from a certain part of your scene. Using black cards to absorb the light that bounces back onto your subject is another way to use subractive lighting and add more to the degree of contrast. Cutting shapes or patterns in a black card and placing it between your light source and your subject matter or background creates a dappled effect; this cutout method is known as "cucalores."

You can use a number of different light sources and accessories to achieve interesting and exciting visual effects. You can combine softboxes with scrims, diffusers, fill reflectors, colored gels, cards and interesting backgrounds and surfaces to get truly dynamic shots. Many of the photos in this book combine one or more of the techniques we've just covered.

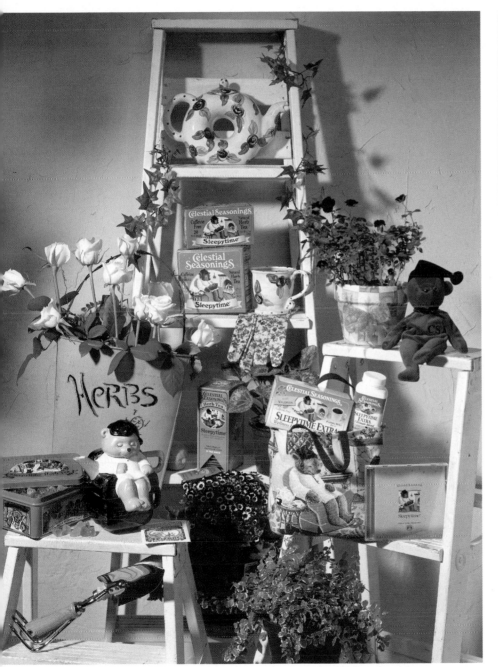

CELESTIAL COVER
© RICK SOUDERS

This image was used for a catalogue cover. We built a textured wall, and used a stylist to arrange the ladders, props, and so forth. The main light is a large strobe reflector placed about twelve feet away from the subject so as to cast some interesting shadows on the wall. A secondary fill umbrella was used at camera right. We also used cards to create shadowing in the upper left corner of the photograph.

Shooting on Glass

Glass and Plexiglas are surfaces, so it is appropriate to include them in this discussion. Shooting on or through glass can be challenging, but it can also make for an incredible effect. There are two types of glass you can work with. There is the common, clear glass that we are all familiar with, and then there is translucent white Plexiglas.

When shooting on or through clear glass, it is extremely important to keep the surface clean and dust-free. To eliminate the risk of unwanted reflections in the glass, wrap light stands, tripods, and other equipment that might reflect in black velvet. Place the glass on steady apple crates, bricks, or some other solid surface about 18 to 24 inches off the ground. Place a white or any other color card under the glass and bounce light from a strobe into the card. Place your subject on the glass surface and light it from whichever direction you prefer. You can even place other objects under the glass to add dimension and interest to the photo. Lighting on glass isn't for everyone, but it is a dynamic technique when used properly. Shooting on white Plexiglas can also make for a very interesting photograph. The interesting thing about white or "milk" Plexiglas is that you can send light through it and take advantage of its color and its light-diffusing qualities. You can also put colored gels on lights under the Plexiglass and shine them through the Plexiglas. Put these lights on a separate strobe pack. Now set your lens on bulb. Make sure your shooting space is dark and that any overhead or modeling lights are off. Open the shutter, and fire the strobes lighting your subject on the Plexiglas. Now hold a piece of clear glass in front of a lens that has been smeared with a light coating of Vaseline, and fire the colored strobes beneath the Plexiglas. Close the shutter, and you will have an amazing image of diffused light shining up around the surface of your subject.

CERAMICS ON GLASS
© RICK SOUDERS

This is another example of the effect of shooting a subject on glass. The glass was positioned about 14 inches from the black marble surface. A laptop computer was placed under the glass. The product is directly on the glass. The main light is a scrim we placed to the right of and above the glass. A strobe with reflector and a red gel were placed low and to the left of the set. We also placed a strobe and a reflector with a purple gel low and to the right of the set. This brought out the true color of the product and underscored the product's use in the arena of high technology.

This photo involved the use of a curved Plexiglas table and colored gels.

Shooting products on white Plexiglas can produce an interesting visual effect. Here, a small soft box is above the set to provide a base illumination. A red-gelled strobe reflector is beneath the Plexiglas. A strobe with reflector is at camera left and another fitted with a blue gel is at camera right. Red and blue lights were fired while the modeling lamps were off and the lens was on time exposure. A piece of diffusion material was then placed in front of the lens and the green strobe was fired.

The Art of Edible Imagery

Food-and-beverage photography is a very specialized segment of the commercial photography industry. This kind of photography may not interest you, but remember that this book is about developing your visual sensibility. Food and beverage photographs are part of the realm of product illustration; it's just that these are edible products. The same issues concerning lighting, color, selective focus, and surfaces that apply to still-life work apply here. This chapter offers both basic instruction on product illustration and advertising photography and a wealth of examples of such images that you can benefit from no matter what kind of work ends up being your specialty.

Shooting Food as a Specialty

Because of its unique focus, food photography requires specialized skills that are not necessarily called upon in other assignments. I want to concentrate here more on developing your awareness of what you see and your sense of what can make a great photograph than on detailed how-to instruction. As you read, refer to the photographs that accompany the text to learn about how certain shots were achieved and for examples of ways to light and style food.

Food photography requires the ability to generate a reaction that isn't relevant to other categories of commercial photography: taste appeal. A food photograph must awaken the appetite and trigger the tastebuds by making the product look as tasty, mouthwatering, or thirst-quenching as possible. In order to give your photographs the power to inspire hunger and thirst, you will need the help of a professional food stylist, but you should begin by mastering the following lighting and camera techniques.

Basic Food-Illustration Lighting

The techniques that apply to successful product illustration can also be used to light a food image. In fact, you'll find that much of the technical information this book offers can be applied to more than one category of

commercial photography. Indeed, in this chapter, you will see several photos that demonstrate techniques introduced in Chapter Four, including selective focus and shooting on diffused Plexiglas. I want you to see how you can apply those methods to working with food and also to show you a new lighting scheme. Several food photographers illuminate their sets, meaning the scene they're photographing, with very large softboxes or light sources that they position above and to the back of the set and slightly off-center from where they have placed the camera. Sometimes these light sources have multiple heads. The instructional photographs included here were taken with a large top or overhead box as a secondary or fill light. The primary light comes from two places: from the side and from a spot, or snooted strobe head, positioned at the back of the set so the light comes skimming across the food. As with any shot, the position of the lights, their power settings, and their distance from the set can be altered to achieve different effects and moods. Keep in mind that your subject is food, and although you might want to give the shot a lot of contrast, or "mood," the food still has to look good and stimulate taste appeal.

NEON SANDWICH
© RICK SOUDERS

YOGURT BOWL
© RICK SOUDERS

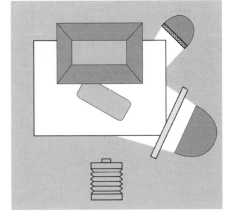

For this simple food shot, I used one main large scrimmed strobe light positioned to the right side of the subject. I placed a medium softbox above the set and slightly behind the subject, and used a strobe reflector with an insert to skim across the set from the back right. Notice the tilted camera angle. Also notice the way the shadow falls forward to give the yogurt dimension.

The purpose of the technique known as back or "rim" lighting is to create spectacular highlights on the food. Highlights can make food look fresh or hot by bringing out its texture and color or making it glisten. Rim lighting is not appropriate for all food items, and as with any still life, you may need to do some experimentation in order to determine what works and what doesn't, which effects you like and which ones you don't like. In the photos on these pages, pay close attention to selective focus, color, composition, and the backgrounds and surfaces. Here you'll see many of the techniques we've been exploring in context.

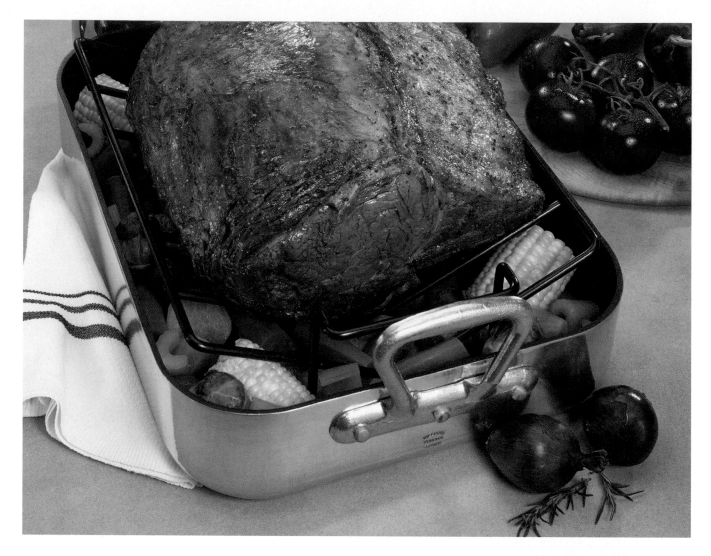

PORK ROAST
© RICK SOUDERS

The diagram for this photo shows how I used a scrimmed strobe reflector light to achieve this shot. A large reflector over the set gave base illumination. I positioned a secondary scrim with a strobe and a large reflector forward and to the camera's left. The highlights on the roast were created by a strong scrimmed light that I placed to the camera's right and at the rear of the set, thus skimming light over the roast.

Combination lighting is another way to light food that you can explore once you get more experienced. This method mixes two or more different light sources, such as strobe light and tungsten light. The light emitted by tungsten bulbs is much warmer in terms of the color spectrum than that of strobes. It is used to warm up areas in a scene that strobes might cause to look too harsh. By using combination lighting, you can achieve brightness in parts of your shot and also achieve warmth and softness in other parts.

SANDWICH GROUPING
© RICK SOUDERS

This image demonstrates many techniques we have been discussing. Notice the environment, or mini set, that I created. This image also illustrates the results of using mixed light sources. The main light is a scrimmed reflector placed to the left of the camera/set. A large softbox positioned overhead provides the base illumination. A tungsten light streams through mini blinds at back and to the left of the set. The strobe modeling lights were turned off, and the set time was about 1/2 second, with the tungsten light left on the entire time. You can vary the tungsten exposure depending on how much "warm" light you want mixed into your shot.

Camera Angle and Perspective

Camera angle and perspective are important in any still-life photo or any image you create, for that matter. I will focus on how each relates to food photography. Camera angle and perspective control the plane of vision from which your viewer will be looking at your subject. You can control the angle from which you take the shot so that the viewer will be looking straight at your subject, eye-to-eye as it were; you can take the shot from a low camera angle, crouching or kneeling so you, and thus the viewer, must look up at the subject; you can take the shot from overhead, and thus look straight down on the subject; or you can take it from the side and get a three-quarter view of your subject from that angle.

There is no such thing as a camera angle that is either right or wrong, but there sure are some unimaginative ones. The lens you use helps enhance perspective. Is it a normal lens? Maybe it is a slight wide-angle or telephoto lens. I will confess that the least-used lenses in my arsenal are the normal lenses. That applies to all my camera formats, from 35mm to 4 x 5. To me, a normal lens is a little less exciting than other lenses. I am not saying there aren't appropriate uses for normal focal-length lenses. I am saying that you should be creative and experiment

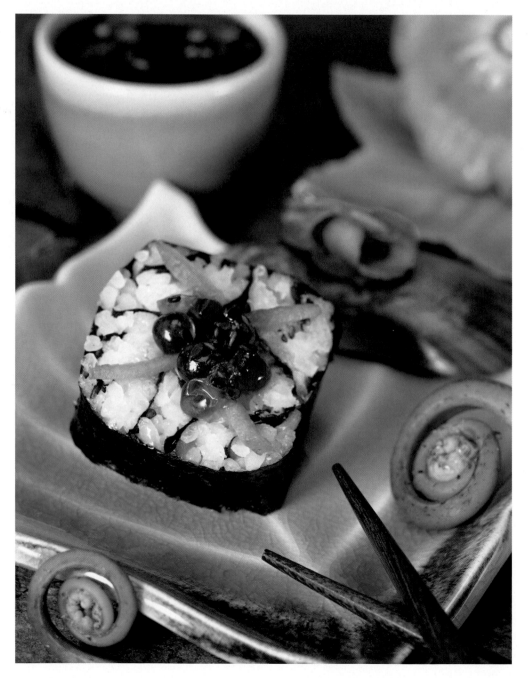

SUSHI
© RICK SOUDERS

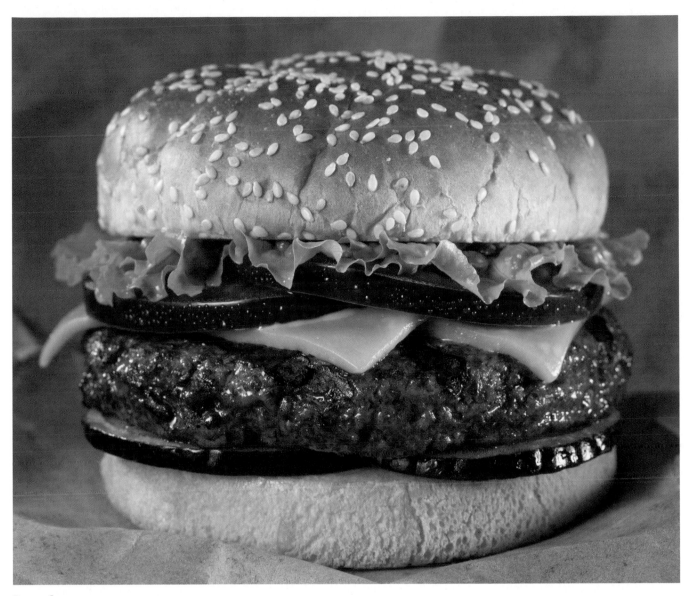

BURGER CLOSE-UP
© RICK SOUDERS

with whatever lens you choose to work with. As you try different lenses, your images will begin to stray from the routine and, if you also shoot from different camera angles and perspectives, they will become more and more interesting.

To demonstrate the importance of camera angle and perspective in food photography, imagine a big juicy hamburger. You are the photographer and your subject is this burger. The client wants the burger to be his advertisement's focus. The client wants the consumers looking at the ad to want to take a huge bite of the hamburger. What can you do to fulfill the client's expectations? Start by shooting from a slightly low camera angle, looking up and into the burger. Use a slightly wide-angle lens as well and suddenly this burger looks hypnotizing. It's a big, monumental, in-your-face, juicy hamburger waiting to be devoured.

Using tight angles and focus on food can also be very effective visually. This is especially true when you don't need to show a whole scene. You can focus all your attention on the food item and compose the photograph with a complete awareness of its possibilities for color composition and selective focus. With food photography, you have to pay special attention to props. Food is

frequently photographed on a plate, a platter, or a preparation surface like a cutting board with silverware or napkins. You must make sure that the color of the plates or accessories you use and the props you select enhance the food and the mood of the photograph. Nothing should clash or seem out of place. If you are shooting Mexican food, don't use Japanese props like dishes or wall hangings. I'm using an exaggerated example of what not to do in order to underscore the importance of props. Your food stylist can help you with prop recommendations.

PAPAYA WITH COTTAGE CHEESE
© RICK SOUDERS

Notice the way I used color, composition, and select focus in this shot.

FRUIT TART
© RICK SOUDERS

Liquids as a Main Course

Beverages are a very specialized subject within food photography. Shooting either food or beverages requires extreme patience. There is usually a limited window of time in which food or beverages keep their "fresh" look before they fade and become unusable. Sometimes you go through multiple set-ups of the food before you get the shot. You can learn a lot of tricks from food stylists. Because my studio specializes in beverage photography, when we shoot, I style all our beverages myself. Don't try this when you are first starting out in beverage photography, however. I want to emphasize that the purpose of this section isn't to make you an incredible food or beverage stylist, but to expose you to the exciting range of possibilities of this category of photography. The light techniques that apply to food photography apply to beverage photography as well, but I will briefly explain some techniques that are unique to working with liquid.

The three basic categories of beverage photography are splash photography, liquid-in-motion, and beverage still-life. Splash photographs show beverages splashing, either

The three basic categories of beverage photography are splash photography, liquid-in-motion, and beverage still-life.

COKE WITH ICE CUBES
© RICK SOUDERS

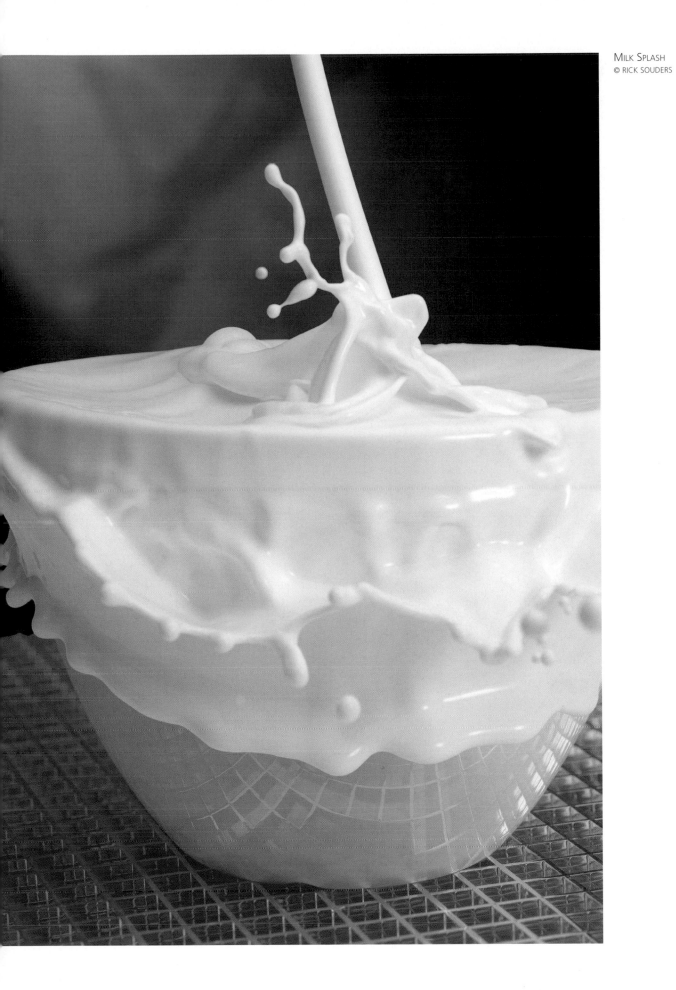

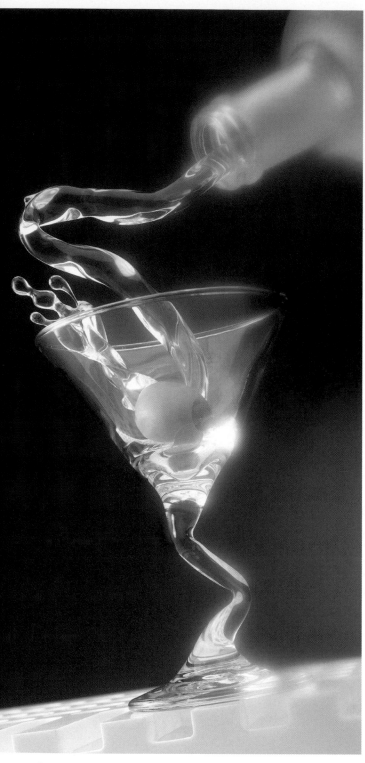

PURPLE MARTINI
© RICK SOUDERS

out of or into cups and glasses. This category can be the most difficult of the three. Liquid in motion involves just what it says: shooting moving liquid. Common assignments involve running water or water streaming over a subject. A beverage still life is a vivid "beauty" shot of a subject like a bottle of wine, a frosty glass of beer, or a steaming mug of cappucino.

I will briefly explain splash photography and its visual power. Because splash photography can be highly technical, I'll use some photographs as examples and explain them in simple terms. My aim is not to endorse specific products, but rather to expose you to this exciting and lucrative part of the commerical market.

The key to splash photography is to use strobes whose flash duration is very brief. Imagine flash duration as an arch. You can't see it with the human eye, but when a strobe fires, the light output starts at a certain level, then reaches a peak of intensity, and then rapidly tapers off. When the flash of some strobes reaches its peak, the light will remain at that intensity for a longer period of time before it tapers off. Such strobes have what we call longer flash duration. The longer a light source stays near its peak, the less able you are to capture a splash or other movement in liquid because the light cannot catch or "freeze" the motion quickly enough. Strobes with very brief flash durations hit their peaks and taper off almost immediately, thus capturing or freezing the liquid in midmotion. When you become skilled at timing and visualizing shots, you will be able to drop an item like an ice cube into a liquid and fire the strobe right at the moment when the cube hits the surface of the liquid. This is difficult, however, and it takes a great deal of experience. An easier way to capture such effects is to find a radio-controlled or infrared device, available from any good photography or camera supply store, that can trigger the strobe for you.

Many times it is impossible to get water or liquid to make the shape a client is looking for. A few companies specialize in making "acrylic" or fake splashes. I use this option several times a year when the client has a big enough budget to cover the expense. Sometimes it becomes the most cost-effective way to achieve the shot. A good splash model will cost you anywhere from eight hundred to several thousand dollars. One of the most tedious and time-consuming factors that comes into play with real splashing liquid is that you have to clean your set after each splash. This is when patience definitely comes in handy.

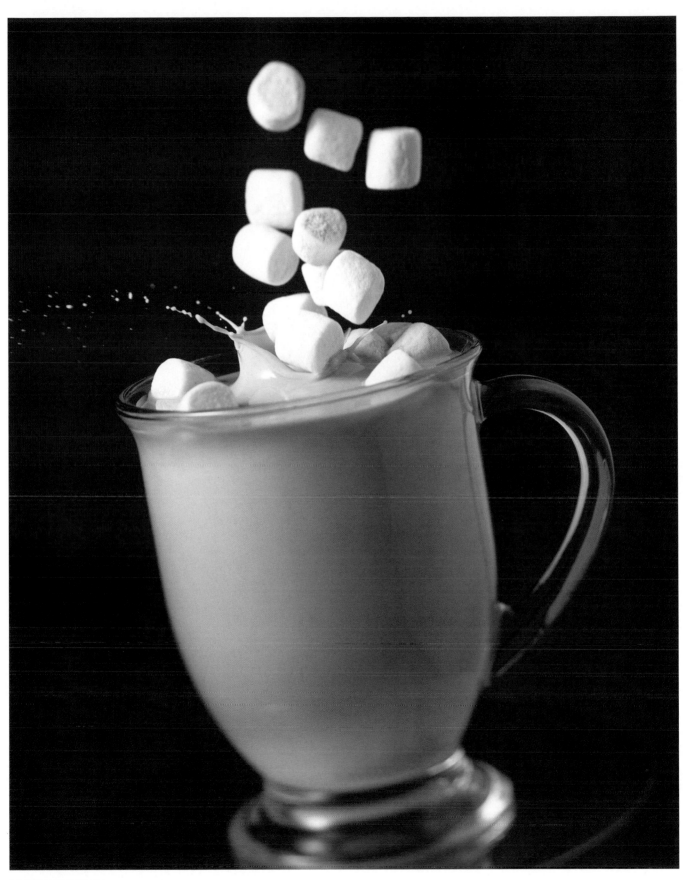

MARSHMALLOW SPLASH
© RICK SOUDERS

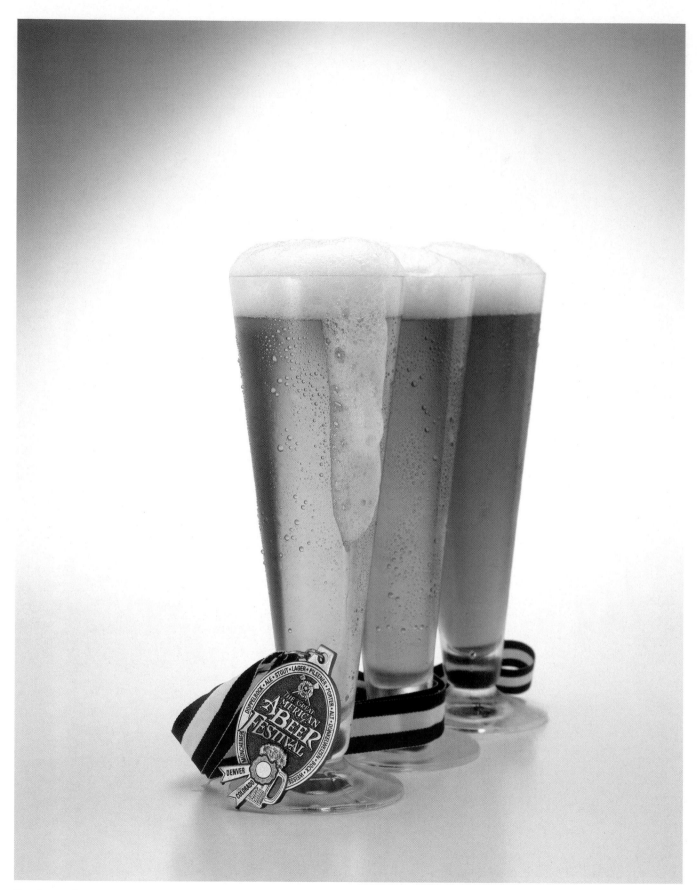

BEER FESTIVAL PILSNERS
© RICK SOUDERS

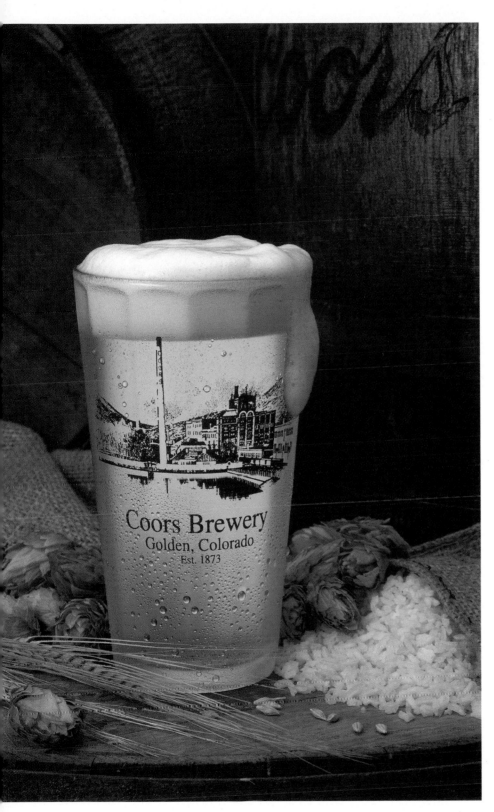

BEER ON BARREL
© RICK SOUDERS

This is a simple beverage shot on a small set. A small softbox is directly over the beer glass. A small reflector card is tilted behind the glass. A scrimmed reflector light acts as the main light and is positioned to the left of the camera and the front of the set.

BLUE SPLASH
© RICK SOUDERS

More than just a splash shot, this photo illustrates the technique of illuminating beverages by lighting their background surface. Here, a main scrimmed light is positoned to the camera's left. A fill card is placed to the camera's right on the set. The background has been lit separately, and that light is what is illuminating the beverage. By lighting the background separately, you can control the brightness of the beverage and the degree of contrast between it and the background.

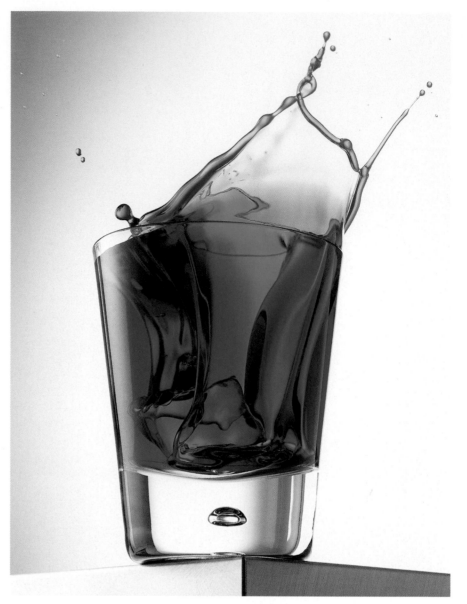

When you're lighting a liquid or beverage, you want light to shine through or illuminate the product. There are three ways to do this.

1. Put a reflector of some sort behind the liquid and point it at one of your light sources. You can make the reflector out of card stock. It can be white, silver, or whatever color works with the color of the liquid you're shooting.

2. Put the liquid or container of liquid on a surface a short distance from its background, and then direct-light the background surface so its brightness illuminates or shines through the beverage.

3. Surround the beverage with light by shooting it on white Plexiglas (see page 56 for details).

Safety is of utmost importance when you are working with liquids around electronic equipment. Never ever sacrifice safety for the sake of "getting the shot." Make sure that all power packs and strobe heads are elevated. Make sure that all strobe cords are elevated or far away from the liquid source. Stop and clean up any water that starts to get near your equipment. Never let water splash onto strobe packs or strobe heads.

Liquid-in-motion is a fun category. You must buy a large, watertight glass container like an aquarium before you venture into this category. To capture liquid in motion, either in midstream or while it's coursing and splashing around a stack of dishes or bottles of shampoo, you must employ a more complicated version of the technique I described for shooting on glass in Chapter Four. You'll need to put the product in the glass container, and you then need to light the container from below as you do when shooting subjects on a glass surface. You can either use running water from a faucet or hose, or liquid that is poured from above. You can use a small paddle to create motion in the water. Start the motion of the water and then fire a strobe. If you use a strobe with fast flash duration, you will freeze the motion of the water around the product. If your strobe has a longer flash duration, some of the water movement will be blurred. This can be a neat effect as well. To get a strobe to better capture or "freeze" motion, use it on its lower power settings. For example, a 2400 watt-per-second strobe pack usually has a slower flash duration at full power, or 2400 watts per second, and a faster flash duration at say 800 watts per second. You'll be able to see any liquid trails or movement in your test Polaroids.

HOLY WATER
© RICK SOUDERS

This photograph demonstrates the virtues of working with moving or running water.

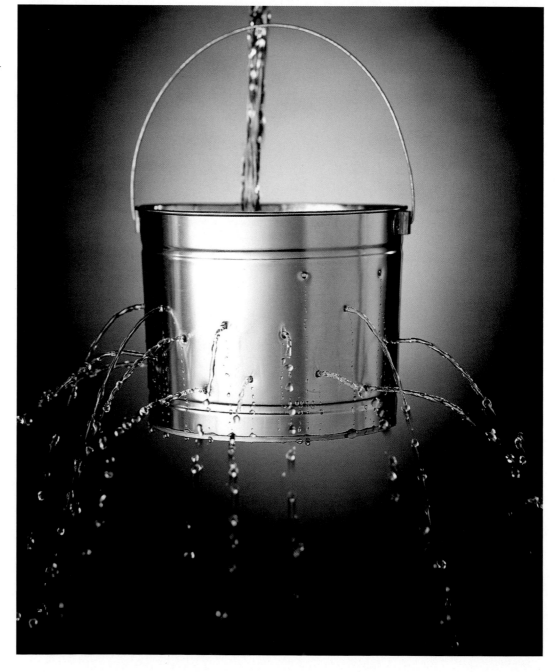

Food and Beverage Styling

A food stylist is a person who specializes in the preparation of food and beverages for photographs and television commercials. He/she may have a background as a gourmet chef or home economist. Food styling takes a lot more skill than simply being a good cook. In fact, very little food that is photographed for commercial advertising purposes is actually fully cooked or edible. Food stylists know how to make meat or poultry look cooked on the outside without really cooking it at all. Those grill marks on burgers, that nice glaze on a ham, their juicy appearance—all these things are fake. I am not a food stylist and don't profess to be one. Even though I have been shooting food for 17 years and know many tricks of the trade, I still let stylists, like Stephen Shern, my primary stylist, do their job. They are experts in preparing the food just as you are the expert in lighting it. A talented food stylist also knows the appropriate props that should go in a specific scene. These include flatware, plates, garnishes, appropriate side dishes and spices, and even appropriate drinks. A good food stylist will charge anywhere from $600 to $1,000 per day and is worth every penny.

Stand-ins are food items that are used on food sets to help photographers light and prepare their sets. Stand-ins are the same size and height as the real food, but they have not been styled for shooting. Since prepared foods generally have a very short life span, you cannot afford to put perfect food in your set while preparing the lighting. Food stylists will help with these props or they will recommend a prop stylist for larger shoots. All of these costs need to be factored into your photography estimate, which we will examine in Chapter Eight.

PORK KABOB
© RICK SOUDERS

Taking photographs that feature fire or flames is always exciting, but they can be a very challenging to capture. Ask a professional food stylist for advice and recommendations for the kind of device you should use to create the flames. Here, I used an exposure of about 1/2 second to capture the flame.

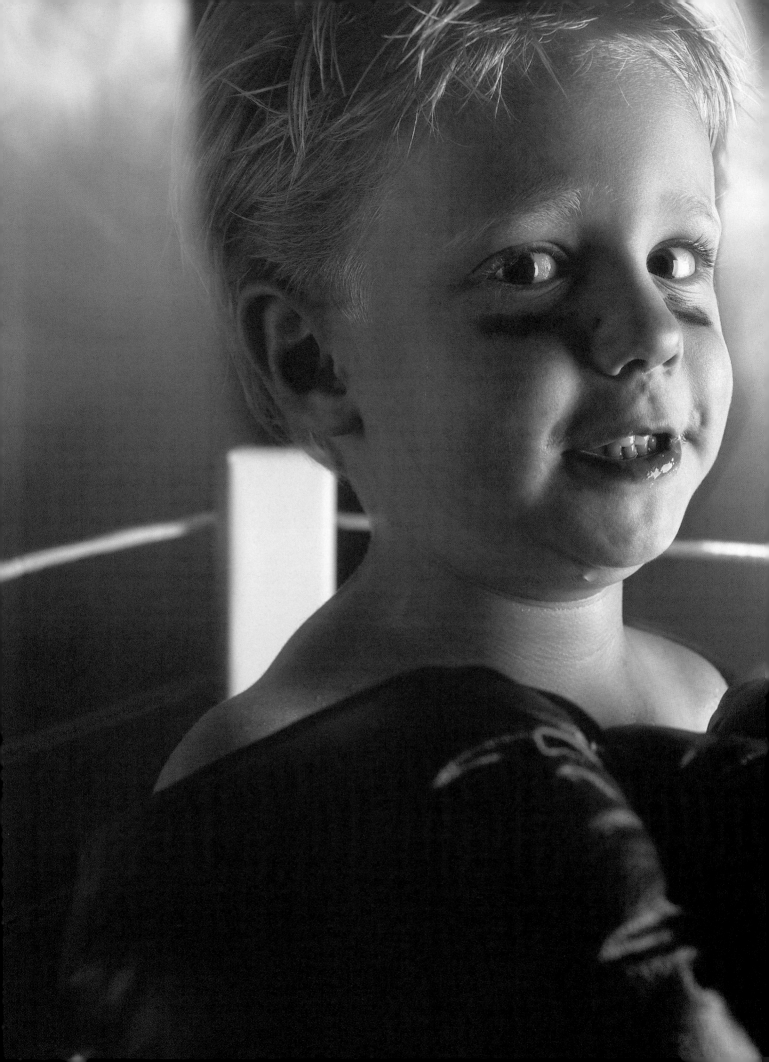

The Art of People

People photography is a broad enough category to warrant the focus of an entire book. Concentrating on some of the more common "people" assignments commercial photographers encounter, however, will show you both the variety that exists within this niche and the similarities between it and other categories. If you want to specialize in people photography, you must learn basic fashion or editorial lighting as well as how to shoot people with products, people "on location," and executive portraits on location. You thus must have experience shooting both in the studio and on location, sometimes outdoors. People photographs are not only used in advertisements promoting specific products but also in lifestyle ads and promotions for charities and other campaigns. They are often used to provoke emotion and to influence people to make changes in their lives, such as giving up cigarettes, for example, or losing weight. If you pursue people photography, you will build an excellent and diverse portfolio that will help you build a career in fashion, travel, or studio product work.

Basic Fashion Lighting

There are many different ways to light people; you can create a trendy, cutting-edge fashion look or a more traditional editorial image. You must learn some basic techniques for utilizing softboxes, umbrellas, large reflector panels, and large strobe reflectors with light inserts. I will explain the basic lighting scenario demonstrated in the photographs on this page and page 81 as one example of trendy fashion lighting. Use a very large softbox positioned off to the left or right side of your subject as your primary or key light. Then offset a large umbrella or large reflector above the camera to add fill. Some photographers create beautiful people photos by using the light reflected from a strobe into a large white panel or card as their main light source. An overhead long, narrow softbox or strip light can accentuate the shine and highlights in your subject's hair.

Whenever you shoot on a set or against a separate background, you will have to decide how to light the background. Again, whether shooting fashion photos or a simple editorial people image, background is important. Make sure that you have carefully considered the background. Simple colored-paper backgrounds are unobtrusive and subtle. Try using some directional lighting with reflectors on the background to create shadowing and mood. You can also crinkle up your paper background and throw the whole thing out of focus using depth of field to give the image an interesting look. Try feathering a softbox on the background. Or try using the "cucalores" technique I described in Chapter Five. Experimentation can create some amazing inventions, and at the very least, if you let yourself, you'll learn something in the process.

SILVER GIRL
© RICK SOUDERS

Here, I used a large softbox placed to the immediate right and slightly above the camera. A 22" reflector on a strobe head was placed directly above the camera. I used a medium strip box above and behind the model to light her hair. The model's silver hair and makeup were professionally styled. The image was slightly underexposed and then overprocessed.

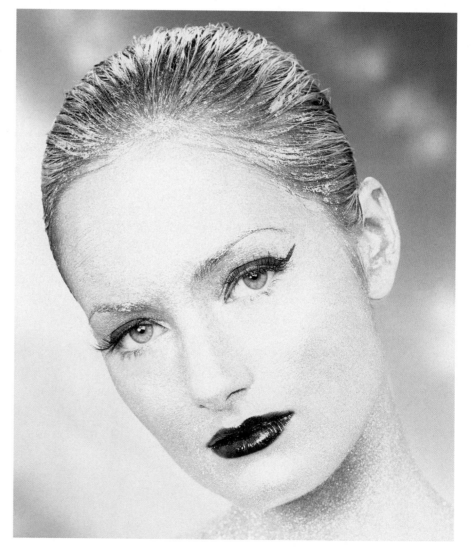

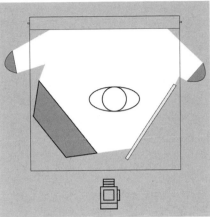

WOMAN IN WHITE
© RICK SOUDERS

A large softbox was placed close to the subject here. A large white 4 x 8 foot reflector panel was used to the camera's right. I focused bright lighting on a white seamless background, and that light "wrapped" around the model on one side. This created quite a dramatic effect.

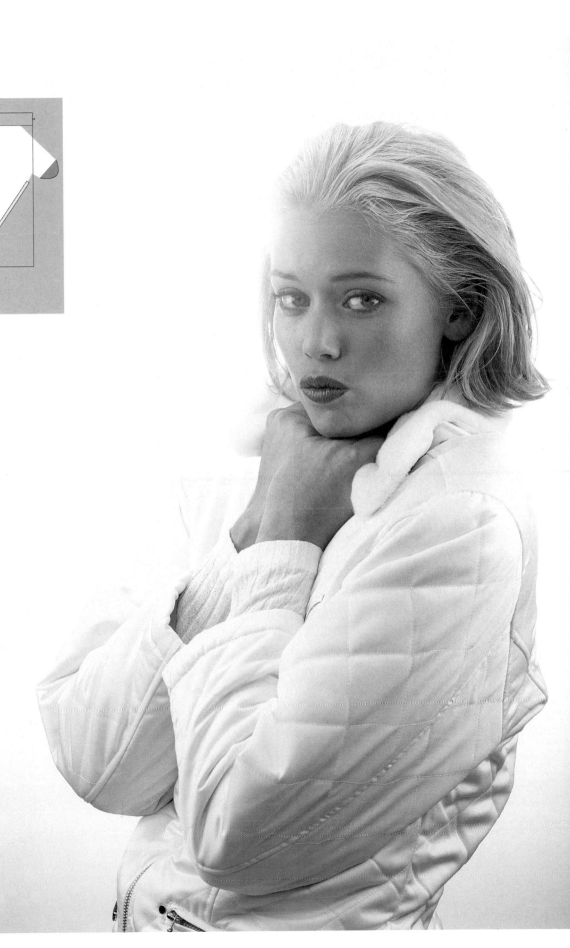

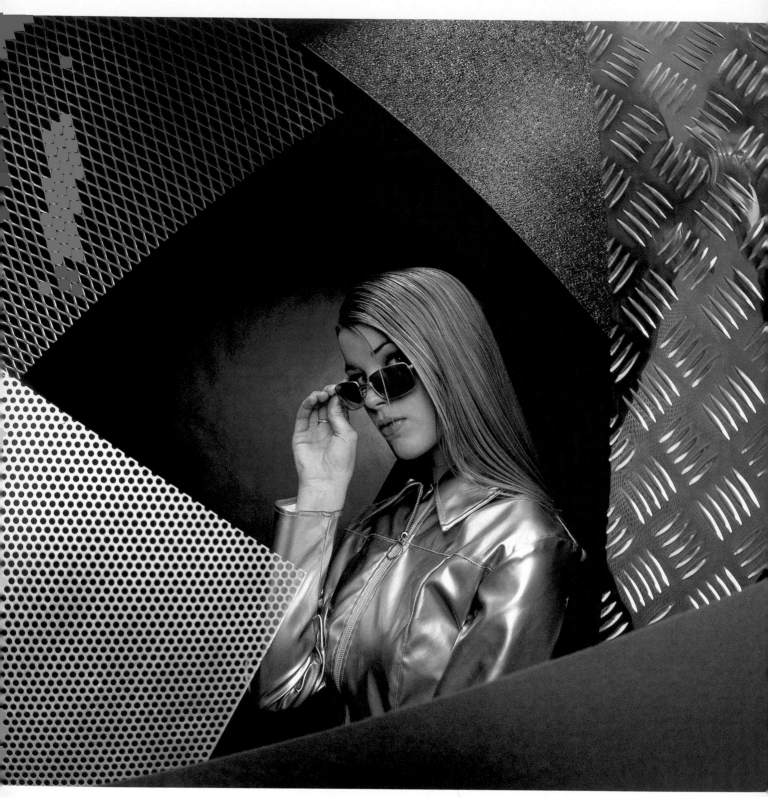

METALLIC WOMAN
© RICK SOUDERS

This portrait was taken with a Mamiya RZ camera and an extreme wide-angle fish-eye lens.

Executive Portraiture on Location

Many corporations or smaller companies use portraits of their executives for use in their newsletters, annual reports, bulletins, or for other advertising purposes. I refer to this kind of work as on location because when you are photographing an executive in his office or outdoors, you are leaving your studio and taking your equipment and lighting accessories out of that controlled environment.

Location portraits often necessitate working quickly and simply. First you need to "choreograph," or frame, your scene. An assistant can stand in to help you decide where and how your subject will be positioned. Look around the space in which you're shooting and decide what you want to use as the background. Once you have decided where your subject will be sitting or standing and what the background will be, you will be ready to jump into the "hustle" mode and decide how best to light your subject and possibly the background. You can use a softbox or umbrella light as your primary or key light. You can use an umbrella or large fill reflector as your secondary light source. Look around and try to use any available resources to make the shot interesting. Sometimes you can take advantage of natural light from a window. Once you've lit your subject matter, decide how to treat the background. There is no one absolute, correct formula. Your choice depends on the mood you want to create. You can use a strobe light with a reflector to create a shaft of light or you can fill the background with an umbrella. Experience and experimentation will teach you the best methods for particular effects.

GLOBAL POSITIONING EXECUTIVE
© RICK SOUDERS

The subject of this photo is an executive in the field of global imaging technology, and I needed to tell his story in an interesting manner. I used a Mamiya RZ camera and a 50mm lens. The main light source was a large softbox placed to the camera's left and an umbrella placed higher up than the softbox. I also positioned a secondary fill light to the camera's right. A gelled yellow strobe shooting through mini blinds illuminated the back left side of the wall.

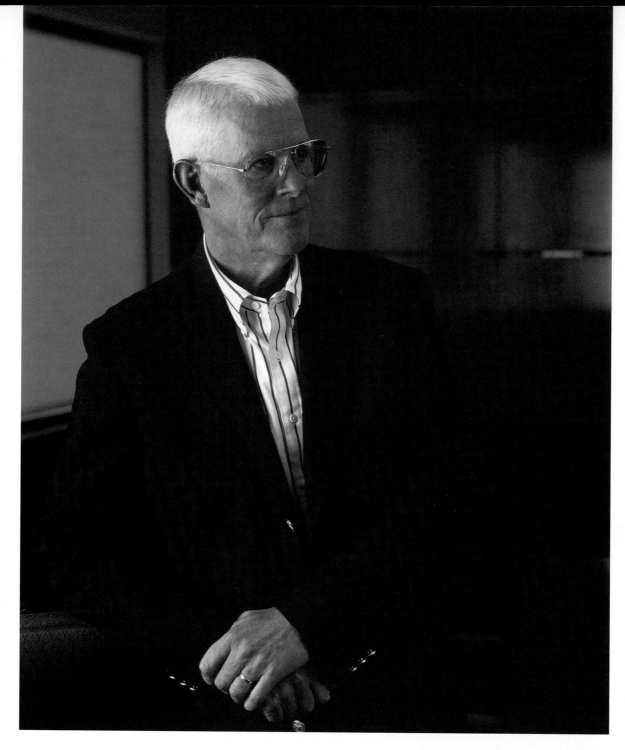

EXECUTIVE IN BOARDROOM
© RICK SOUDERS

We only had 15 minutes to photograph this busy executive for his company's annual report. He is in a boardroom next to a chair. I placed a large softbox to the left of the camera. A bounce fill strobe light is camera right. I then used a very slight time exposure to make the most of the daylight coming in to the left of camera. The result is a classic but interesting portrait.

You will undoubtedly be in situations where you will have little time to spend with your subject, who, as a corporate executive, is often very busy. I average 15 minutes per person for most of the annual report and executive portraits shots I do. If you haven't previsualized your shot, 15 minutes doesn't leave you much time to get the lighting right. I recommend getting to the assignment location 45 minutes to an hour before the shoot and using an assistant or some other stand-in to help you determine the best lighting and composition. As you compose the photo, keep in mind that composition is just as important in people photography as it is in still-life or other product photography. Make sure that the background doesn't compete with your subject. Make sure the subject is not standing in front of any columns or poles that will look as if they're coming out of the subject's head. Make sure that there is no unwanted clutter on desks or otherwise in the background. If the scene doesn't look right when you look at it through the camera lens, it will probably look worse on film. Instant Polaroid shots or digital camera previews are an excellent way to correct compositional mistakes or see whether you've captured the look you're after.

EXECUTIVES IN MANUFACTURING FACILITY
© RICK SOUDERS

This is an example of how to create an interesting group executive portrait in a seemingly uninteresting industrial setting.

People with Product

Photographing people with products is a gigantic component of the commercial photography industry. Advertisements of countless consumer products such as food, cars, homes, toys, and clothing feature photographs of people with that product. Such ads may just feature a person's hand holding a product, or they may show a person or a whole group of people inside a home. For such shots, you have to light both the people and the product. Oftentimes you'll need to use a combination of lighting techniques to create an effective photograph.

Whether you are working in the studio or on location, always previsualize your shots. First, determine what the person will be doing in the photograph, i.e., sitting, standing, or moving, and then frame them in-camera with the product. Here is a simple and useful rule of thumb: light the scene for the person first, then see what you need to do next to light or enhance the product. Sometimes you will need an additional light source or perhaps a fill card or reflector for the product. You need to think through the lighting on the person, the lighting on the background or environment, and the lighting on the product in relation to the size or scale of your shot. If you separate these elements in your mind when you are previsualizing, it will help you decide on the best and most creative lighting scheme. Don't be afraid to try new ways of working with light, to help you define your shot.

It is worth noting that in this age of digital composition, photographers are often asked to light and shoot a person with a product and then to light and shoot just the product by itself so it can be stripped back into the original shot digitally. This provides the client with the "perfect" lighting scenario for the product. The two photographs are scanned and converted to digital images that can then be combined or otherwise altered using software such as Adobe Photoshop.

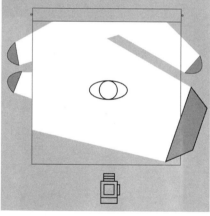

MAN. WITH WATCH
© RICK SOUDERS

For this shot, I directed a main light from the right side of the set on the subject and the hand. I used a blue-gelled fill light to illuminate the shadows. Separate lights were used to illuminate the mottled canvas background. I used a 50mm lens on a Mamiya RZ camera.

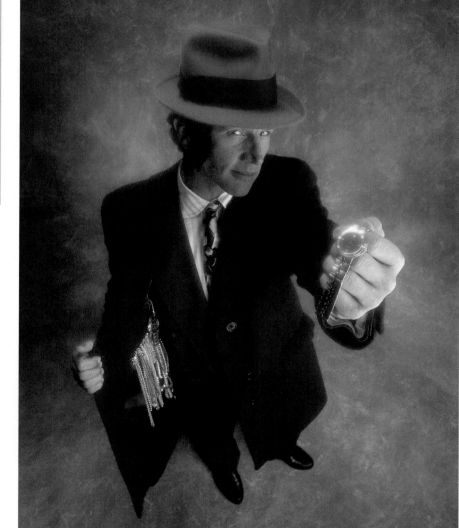

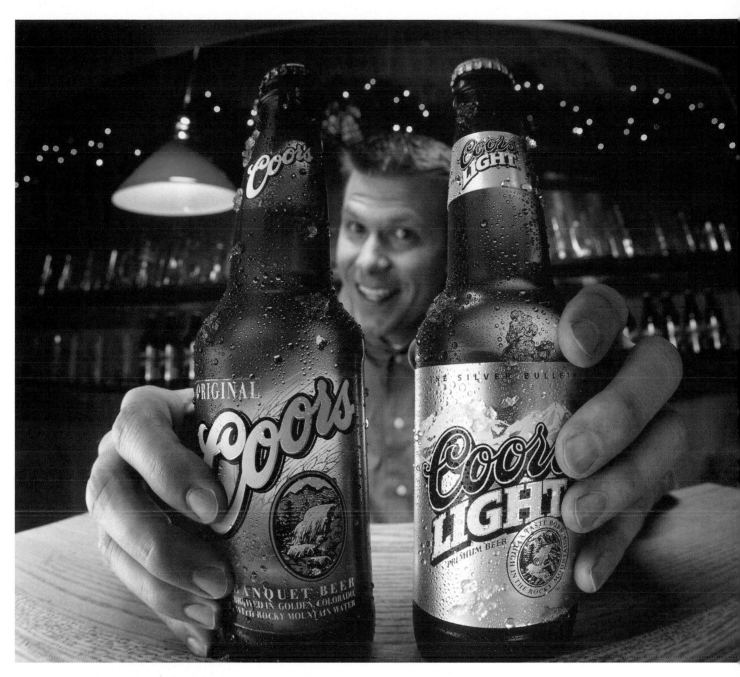

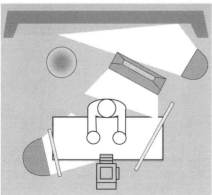

Bartender
© RICK SOUDERS

We built the oak bar surface and shelves to create the studio setting for this photo. We suspended a green bar lamp for mood and to create some depth. I used a Mamiya fish-eye lens poised about eight inches from the product. The main light is a scrim placed at the camera's left, and I also placed a fill reflector card at the camera's right. To light the model's hair, I positioned a strip light over him and to the right. Another strobe with a large reflector helped illuminate the back bar.

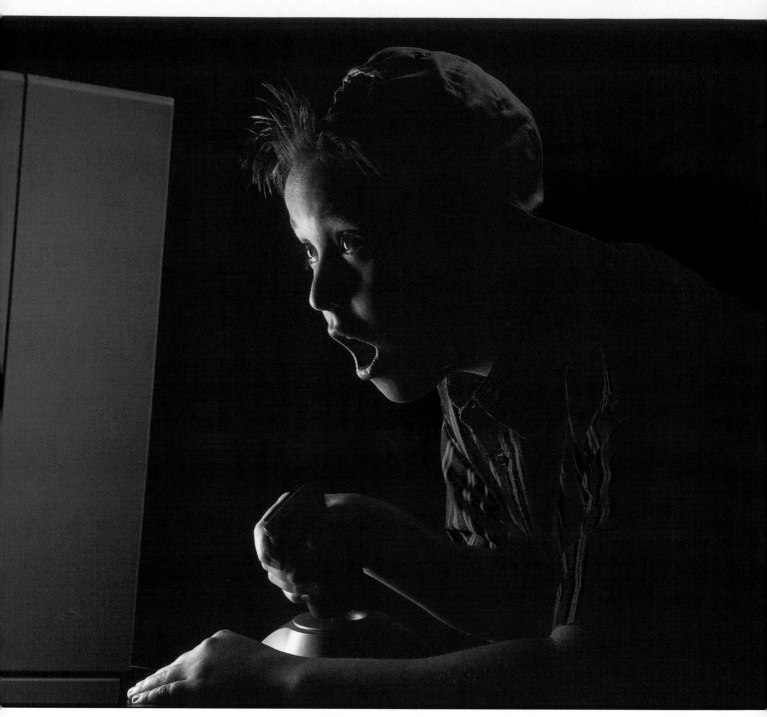

BOY AT COMPUTER
© RICK SOUDERS

This shot features a very simple lighting scheme. I put a soft box directly next to the computer monitor to simulate the monitor light, and I used a back rim light to separate the boy's cap from the background. The background is a black surface illuminated with the help of a purple gel.

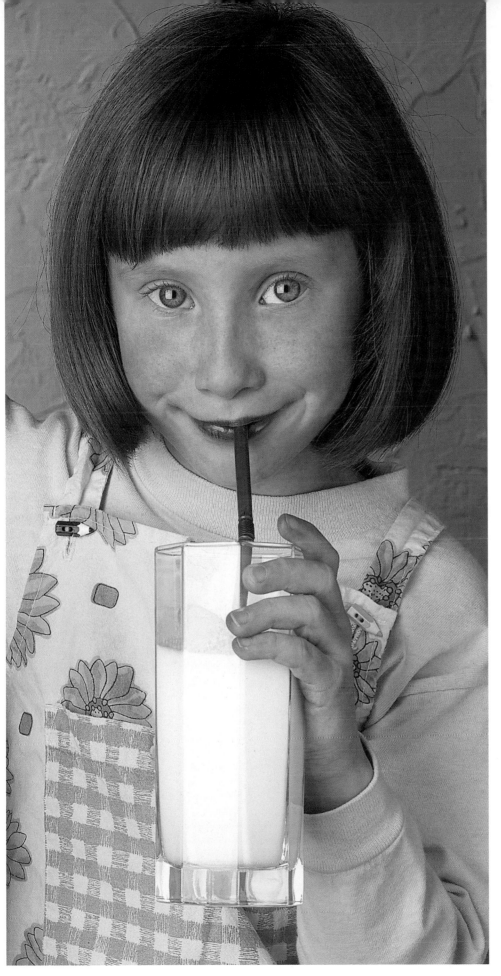

People on Location

In this section, we will look at ways to take on-location photographs in outdoor settings. I have introduced some basic ways to light "people with product," fashion, and portrait photography, but I have not discussed how to light outdoor shots. Here are two basic ways to approach outdoor lighting. You can use whatever natural light is available and fill in shadows as necessary with either reflectors or strobes. You can also place your person in shade, light them with a stobe, and then balance that light with any ambient background light.

It is a matter of placing your subject in the scene and composing your shot. Then, to fill in any harsh or unwanted shadows, you can use a white (shiny or dull) or gold (shiny or dull) flex fill. The example on page 91 demonstrates shooting on location in natural sunlight where strobe fill would not be appropriate. In this case, I used a shiny gold flex fill.

The second method of lighting people in outdoor settings that I've introduced involves placing your subject in an open, shaded area and then lighting him/her with a strobe. You balance the strobe with any background light in the scene, such as glimpses of sky. The easiest way to learn how to do this is to use a small or portable handheld strobe off-camera to light the person. Taking some instant polaroids to test the effect first is a very helpful way to preview what you will actually be capturing on film.

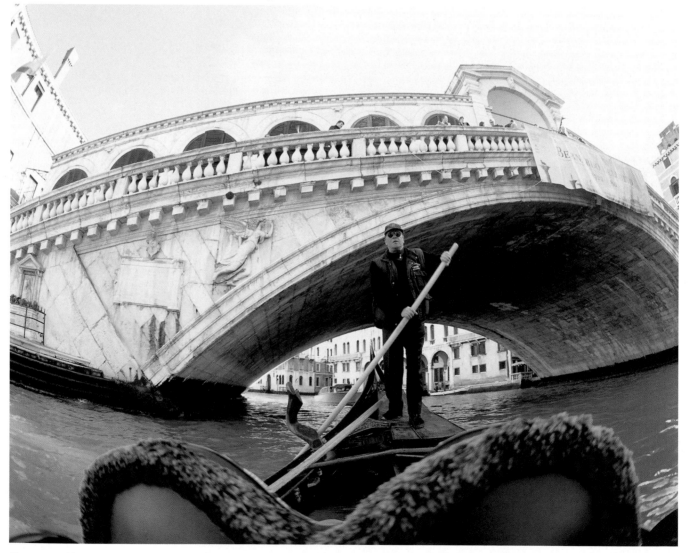

GONDOLIER IN VENICE
© RICK SOUDERS

The lines and curves of the bridge and the shape of the gondola are integral to the successful composition of this this photograph.

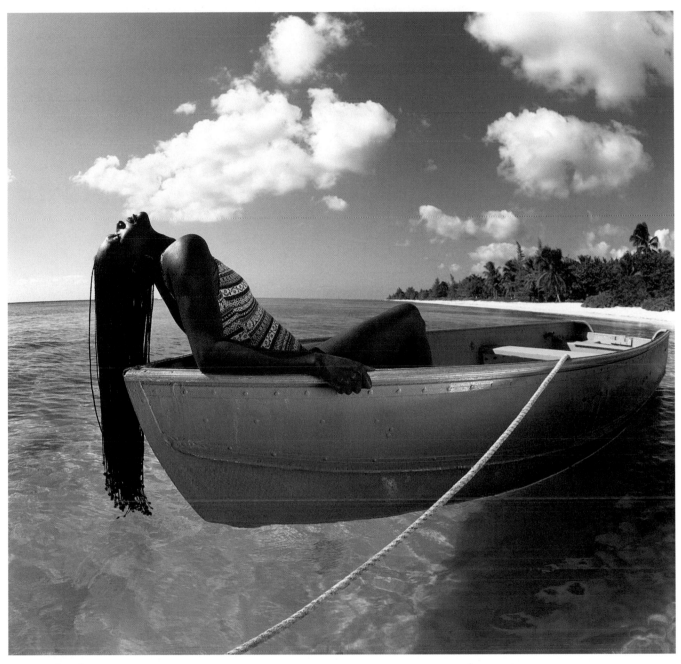

WOMAN IN BLUE BOAT
© RICK SOUDERS

This shot was taken outdoors with a simple flex fill reflector. A flex fill is a circular fabric fill on a spring frame so it "pops open" for easy use. It has rigid sides so it is easy to hold.

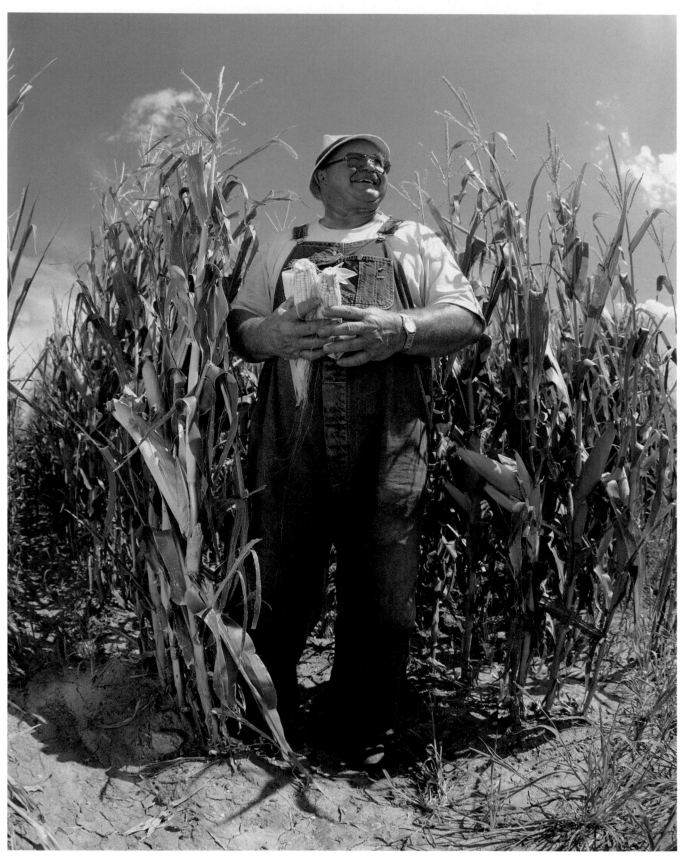

FARMER JEAN
© RICK SOUDERS

This outdoor shot was taken with a simple flex fill to open up shadows.

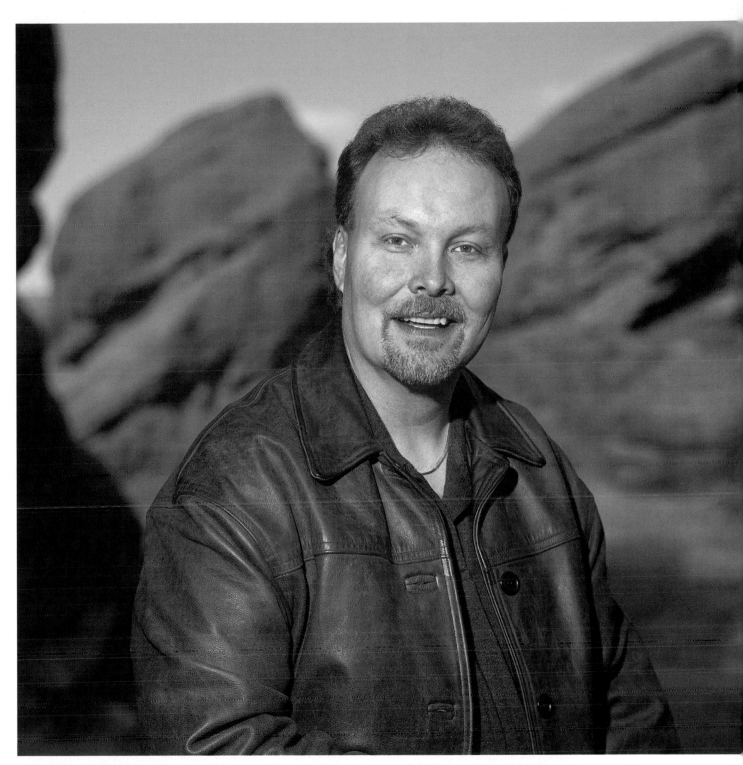

Professional Guidance

When shooting advertising assignments, oftentimes you will need to hire professional models. Clients have a specific target audience or portion of the demographic to which they want to market their product. This means that they know the target age-range, sex, and general lifestyle of their desired audience. Marketing is a very

LADY IN BLACK
© RICK SOUDERS

This is a simple yet
strong people
photograph for
which I used a
professional model
and professional
stylists.

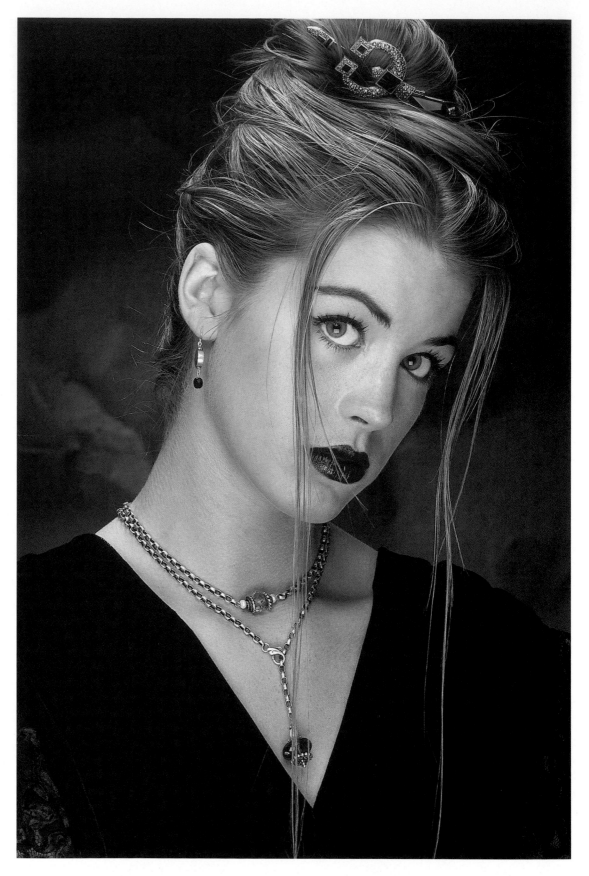

sophisticated and costly process that clients use to pinpoint exactly who will purchase their products. Therefore, they know exactly what kind of people they want to use in their advertisements. They could specify that they want to use a middle-aged, balding, Caucasion man or a fit, healthy, teenage blonde female. You will sometimes be asked to help select a model, so you should make sure you are familiar with all of your local talent or modeling agencies. You can get the appropriate "look" requirements from your client and then pass them along to the talent agencies, who will assign an agent to provide you with model "head sheets," or descriptions with photos, that meet your specifications. They can also select actual models for a casting session. A casting session is a block of time in which you've set up appointments for the models to come to your studio. You take a Polaroid shot of each model you think might be appropriate for the ad and show it to the client in a separate meeting.

Don't forget to bill the client for the time it takes to conduct a model search. Your time is worth money. Translate the cost for this time into a "casting fee" or as a production coordination fee. Some photographers bill their time at an hourly rate; others have a standard flat rate for casting. Check around and determine what works best in your market. I will discuss pricing and business practices in detail in Chapter 8.

We've discussed professional talent briefly. Make sure you understand whether the client is being billed directly for the use of the model or whether that fee will be included in your bill. If it is, make sure you estimate the cost very accurately. The standard rate for models usually starts at between $100 and $150 per hour and goes way up from there. It is important to know how long you will need the model. **Also keep in mind that when you are estimating jobs requiring models, you should tack on an additional 20 to 30 per cent, to cover the talent agency's handling fees.**

Professional make-up, hair and wardrobe styling are also critical parts of a successful people photograph. Sometimes hair and makeup stylists are one and the same. In larger markets, people specialize in either hair or makeup. Getting the right hairstyle and image is critical. Stylists are another expense involved in the shoot, but they are worth every penny you pay them because they can really make or break a photo session.

So what does a wardrobe stylist do? That's a great question. A wardrobe stylist obtains clothing and accessories for a photo shoot based upon the following criteria:

- Who the model is and what he/she looks like.

- The objective of the photograph or image.

- The demographics of the client's desired audience. Who are they targeting?

As you can see, the wardrobe stylist must be very knowledgeable about fashion, clothing styles, "looks," and trends. A good wardrobe stylist is invaluable to this particular kind of photography.

Model Releases—A Must

A model release form is a critical part of the way you do business. You cannot rely on a person's word if they give you permission to photograph them. Whenever you use a person as your model, you absolutely must get their permission to use or publish that photograph by having them sign a model release. This form will spell out the manner in which you are legally entitled to use the photograph. For example, the images might be published in a magazine article or newspaper insert, or they might be used on an album cover or in a consumer ad. A model release proves you received permission to photograph a person with the understanding that they have authorized you to reuse or sell the image. If you don't get use these releases, in most cases, you are opening yourself up to a lawsuit.

Most advertising agencies, magazines, and stock photography companies require copies of model releases before they will publish images. **It is the photographer's responsibility to get these releases.** Model releases can be either very simple or very detailed. I choose to use detailed releases for the photographs I used in this book to guard against legal problems. I am including a sample release form on page 96 for you to adapt to your own purposes.

While on the subject of releases, it is imperative for the photographer to check on property-release requirements. If you are in a recognizable place like a restaurant or a sports arena, on private property (other than your own), or in a national park, chances are you need a property release from the proprietor or management to shoot there. (Sometimes you have to pay "permit fees" in lieu of an actual release.) Included here is a sample property release.

MODEL RELEASE

In consideration of the payment to me by _____("STUDIO") of the sum of $_____, inclusive of all agency fees (if any), I hereby represent and agree as follows:

1. I hereby irrevocably grant to _____ its subsidiaries, assignees, licensees, their employees, agents, or representatives (the Grantees) the right to copyright, use, record, advertise and publicize my name, likeness, or voice in photographs, recordings, both audio and video, or other reproductions of my physical likeness in which I may be included, and all ancillary and subsidiary rights to the above, in all media now or hereafter known, for any lawful purpose **without any restrictions** unless otherwise noted here.

2. I waive any right to inspect or approve any picture or likeness so used or the copy used in connection therewith, or to which it is applied. I release, discharge and agree to hold harmless the Grantees and those acting under their permission or upon the authority from any liability resulting from the production, reproduction or use hereunder of my picture or likeness, including for any optical illusion, alteration or other circumstances that may occur or be produced in connection therewith, whether intentional or otherwise.

3. This Agreement shall be governed by the laws of the state of _____.

4. This Agreement expresses the entire agreement between the parties and no modification shall be effective unless it is in writing and signed by both parties.

5. I hereby warrant I am twenty-one years of age or over, (or I am authorizing the use of this photography for a minor in my custody),and have every right to contract in my own name in the above regard and further that I have read the above Release, prior to its execution, and I am fully familiar with the contents thereof.

SIGNATURE	DATE
PRINT NAME AND ADDRESS BELOW	**FOR STUDIO INTERNAL USE ONLY**
	PROJECT
	JOB NUMBER
	ART DIRECTOR
	PHOTOGRAPHER
AGENCY	JOB DATE

YOUR LOGO HERE

PROPERTY RELEASE

DATE:	JOB #:	CITY:
Photographer:	Title:	County:
Art Director:	Client:	State:

DESCRIPTION:

For valuable consideration, I, the undersigned, having the right to permit the taking of and use of photographs of certain property, in whole or in part, designated as:

do hereby irrevocably consent to the unrestricted us by _____, its subsidiaries,clients, customers, successors and assigns of the property's name, and all photographs taken of said property this day, for all purposes, including without limitation, art editorial, advertising or trade, without any further compensation to me for property owned by:

NAME:	
ADDRESS:	
CITY:	
STATE & ZIP:	

I do hereby waive any right to inspect or approve the finished photograph, advertising copy, or printed matter that may be used in conjunction therewith, or to the eventual use that it may be applied.

In conjunction with the foregoing, I hereby release and hold harmless _____ and each of the above from all liability.

I warrant that this agreement constitutes the sole, complete and exclusive agreement between myself and _____ and I am not relying on any other representation whether oral or written.

SIGNED: (Owner or Agent):	
PRINT NAME:	
ADDRESS:	
PHOTOGRAPHER:	
WITNESS:	

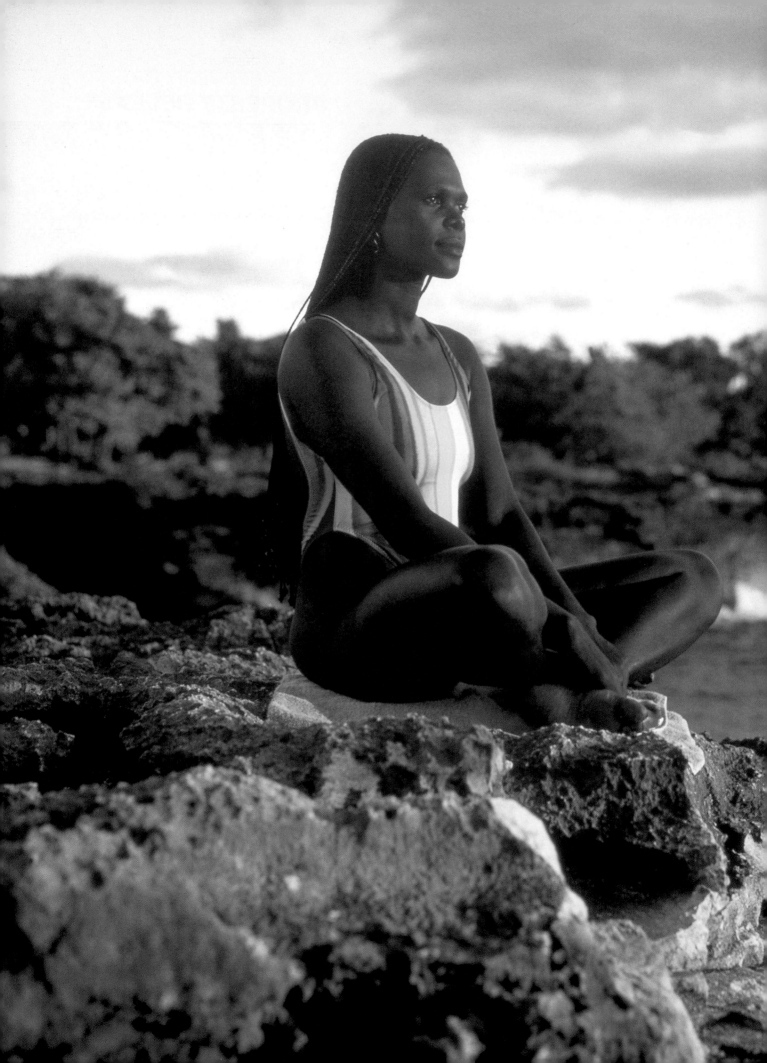

Areas of Specialized Focus

If you use the list of career possibilities in Chapter One as a gauge, you'll realize that we have barely scratched the surface of the various career opportunities that exist in the commercial photography industry. In fact, several books would only begin to adequately cover the entire range of categories within the business. Whole books have actually been devoted to very specialized areas of the field such as architectural, portrait, food photography and many others. So far, this book has touched on some fundamental components of the industry by discussing product illustration, food-and-beverage photography, and people-and-lifestyle photography. Even though the unique aim of this book is to blend a discussion of the art of photography with an appraisal of the attitude and business practices necessary for success, I would be remiss if I didn't also touch briefly on some other important and lucrative areas of the profession, namely stock photography, travel photography, architectural photography, nature photography, and the new digital photography frontier.

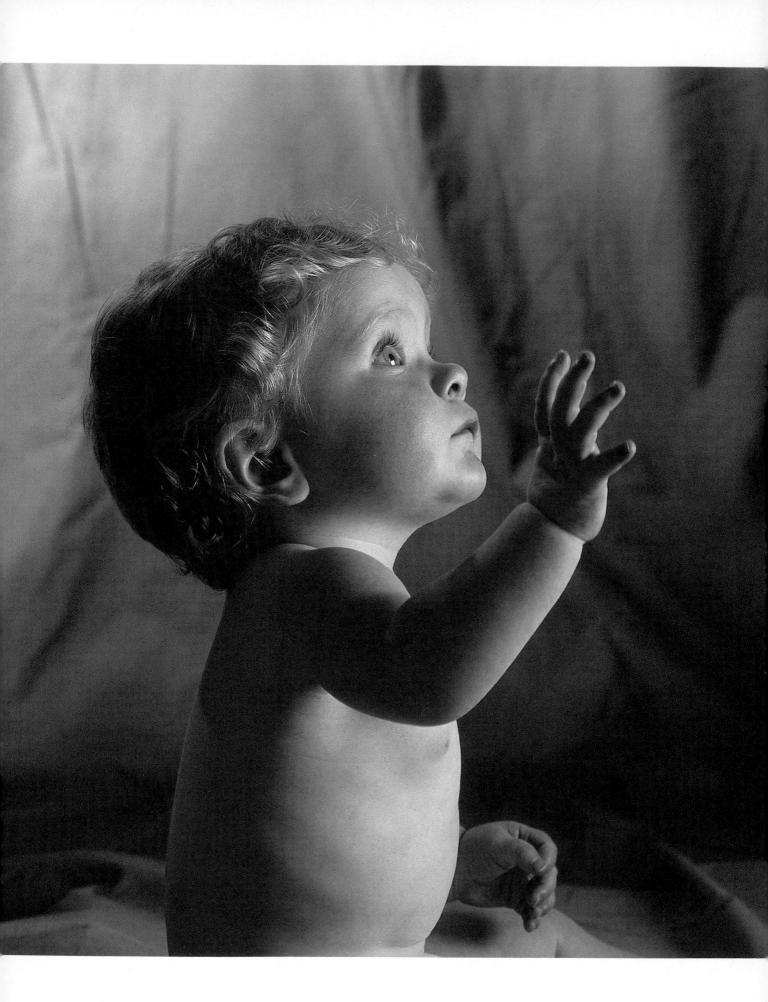

Stock Photography

Stock photography can have any of a number of subjects, including all those we have discussed (products, people, or food and beverages). Stock photographers have a library of photographs of all different subjects to which they continually add, and that they make available for clients to purchase for use in publications or advertisements. Some photographers advertise, manage, and sell their own "stock" of photographs, but many belong to a stock photography agency. These agencies represent several different photographers and market their images to prospective clients through catalogues and the Internet.

There are two kinds of stock photography. The first consists of photos that were originally taken for another purpose or assignment, or that were meant to be sold to a different buyer, that the photographer later submits to a stock agency to sell. The second kind consists of photographs originally shot or undertaken for the purpose of submitting them to a stock agency to sell. Stock photography gets more and more creative each year, and so it becomes an increasingly competitive field. Stock agencies typically pay the majority of the costs for advertising and collecting payments from clients. The agency usually retains 50 percent of the proceeds and passes the other 50 percent on to the photographer. There are all kinds of stock photography needs and many different photographer agreements to meet those needs. Let's talk about how you initially start a stock photography portfolio and how you can get the attention of those stock agency editors.

BABY ON CANVAS
© RICK SOUDERS

A simple portrait of a baby with a canvas background is an excellent stock image. Stock photography is very competitive these days, so your work in this field must be creative and market savvy.

First and foremost, you need to sell yourself to the stock agency. There are literally thousands of photographers out there, and the giants of the stock agency industry have thousands of contributing photographers on contract. To sell yourself, you need a product. Your product is the area of photography that you enjoy and in which you specialize. A handful of scenics, a few still-lifes, some architecture shots, a few people shots, and a few beautiful vacation grab-shots will not win you a contract with a stock agency. Most agencies want to see a specific number of photographs submitted in a very particular, formal manner. Before you submit anything, first visit their Web sites. Then call or e-mail them with additional or specific questions you may have. Some agencies require an initial submission of about 100 images, while some want at least 500.

PUPPY IN WAGON
© RICK SOUDERS

I took this portrait of Mousse, our studio mascot, to use on the studio Web site and also to have on file as a stock photo.

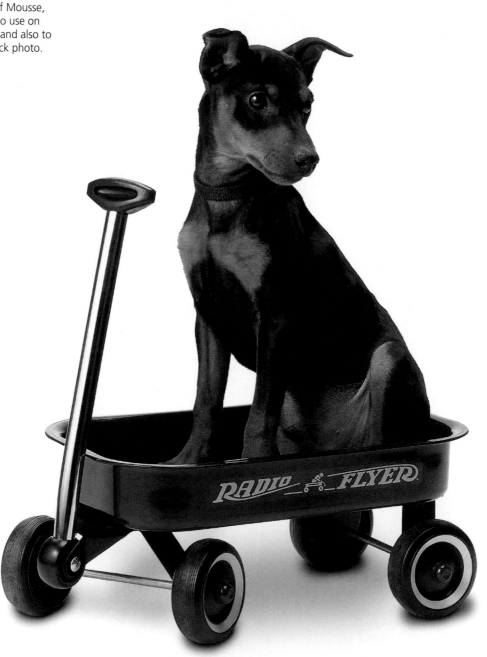

There are submission rules and guidelines regarding original transparencies, digital or electronic files, prints, and so on. There are also specific guidelines for numbering images and providing captions to which you must adhere. The submission requirements vary slightly from one agency to another. Once an agency takes you on as a contributing photographer, they will often ask for exclusive rights to sell the images for you. This means that, unless you make special arrangements with them, you cannot sell the same or similar images through another stock agency. There are also guidelines about how often you are required to submit work. Please make sure you understand your contract, what is required of you, and how your images are being sold.

The number of stock agencies has dwindled dramatically in recent years as the industry giants have

WIDE ANGLE PORTRAIT OF MAN'S BEST FRIEND
© RICK SOUDERS

bought out a lot of the small agencies. You need to adapt if you are going to survive one agency sale to the next. The good thing about working within stock photography is that the world is at your fingertips. Most agencies still produce four-color catalogs for their clients. But their strongest tool is online promotion and sales. Now clients and potential clients can browse agency stock libraries and gather images they want to consider in a shopping cart. Clients can even print very low-resolution, low-quality images for client presentations. The Internet has made it easier than ever for clients to have a huge library of images at their fingertips. It has also made it possible to purchase those images electronically, thus streamlining the process.

Sometimes controversy arises about the usage of stock photography and the way it is sold. Some agencies still command high prices for traditional print ads and billboards. Royalty-free stock photography is at the other end of that pricing spectrum. This is a scenario in which a client buys access to a particular bank of images stored on a Web site or CD-ROM. The client can then use the images for any purpose, for any usage for an unspecified amount of time without any further compensation to the image creator. The small mom-and-pop desktop publishers who need one-time images for small flyers, brochures, and newsletters and who pay (not a lot but something at least) represent the clients in the middle of the pricing spectrum.

TONY AWARD
© RICK SOUDERS

My challenge for this assignment was to make the award the "hero" of the photograph and present it from a dramatic and unexpected angle.

I took this patriotic portrait with a Mamiya extreme fish-eye lens on location using a reflector fill.

This book will not debate the ethics of high-paying specialty stock images versus royalty-free photography. The intent here is merely to expose and educate the reader to the various aspects of this particular part of the industry. You will participate in the market only if you choose to, at the level at which you feel comfortable.

Stock photography is a field as large as commercial photography itself. There are agencies that specialize in medicine, health, plants, astronomy, people, travel, food, landscape and scenic photos, wines, and travel.

Architectural Photography

Architectural photography is the art of shooting man-made structures and buildings. The subject matter includes building exteriors, interiors of rooms, or even architectural details such as tile, windows, decorative pillars, or arches.

Such photography is used by home and commercial property developers, city planners, real estate agencies, in real-estate brochures, and in many other applications. Architectural photography requires a great understanding of light and great lighting skill, sometimes requiring a combination of natural and strobe or tungsten light. There are many great architectural photographers out there whose work you can research. There are also several books on the subject that you can find at your local library or bookstore.

Nature Photography—Is It Commercial?

Although it may seem to belong more to the world of fine art photography or to a realm of its own, if you were to ask many of the photographers who specialize in nature and landscape work, they would probably say that they work in a specialized segment of the commercial photography market. The fact is that scenic and nature photography is used millions of times a day around the globe in ads, books, postcards, and calendars. You've seen this kind of photography in both color and black and white. I won't attempt to educate you here about becoming the world's next great landscape photographer. However, the ability to visualize, see, and translate creative vision to film is essential to commercial photography. Nature photography makes you see your planet in ways you may have never seen it before, and that's the reason I am discussing it here. The next time you are traveling or even looking at beautiful landscape photography, for that matter, look at the scene's composition and lighting. Look at the camera angles, the shapes, and the whole feel of the scene.

You may use nature's own lighting tools with this type of photography, but one thing is for sure: you still have to be able to see beyond the obvious when creating an image. You have to orchestrate a shot with lighting, shapes, composition, and color, just like you would for any other image. Patience is a virtue here. The great scenic and landscape artists can spend several weeks at the same location looking for the perfect combination of sky, clouds, color, wind, water, and luck.

Nature and landscape photography is appropriate for all camera formats. Many photographers shoot nature photography with a 35mm system because it is highly portable. You can get several of these camera bodies and lenses into a backpack for back-country hiking or into rough terrain. That isn't to say there aren't medium-format and large-format cameras that are lightweight and compact. In fact, you can find quite a selection of lightweight 4 x 5 field cameras that are much lighter than their studio counterparts.

Nature photography can be defined as both fine art and commercial art. Sometimes these labels can be confusing. Look at the various applications for nature photography, and then you can make the distinction in your own mind. An example of fine-art nature photography would be a gallery show of beautifully executed black-and-white landscapes. The artist's intent was to transform or perhaps just share the landscape he experienced with his lens and his artistic vision. These images are supposed to hang on the wall and be appreciated for their aesthetic value. You can go into almost any reputable photography gallery and find wonderful examples of both black-and-white and color renderings of landscapes, seascapes, and other natural scenes. You will notice that the photographers, at least the good ones, sell their work in such galleries for a handsome price.

Back to our discussion of nature photography as commercial art. Just think about the endless possibilities. Many nature or landscape photographers are hired or commissioned for their very special skills. They may be contributing to a book about a specific region or country. They may be commissioned for specific ad campaigns that want to capitalize on the beauty of nature. An advertising agency generally would not hire a studio still-life or people photographer to shoot landscapes. People hire the

URBAN LANDSCAPE IN INFRA RED
© TREVOR MOORE

Infrared film makes this urban landscape extraordinary.

professionals from whom they know they can get great scenic images. You should also note that this type of photography sometimes crosses into the categories of stock photography and travel photography. Many nature photographers make a substantial portion of their incomes by submitting their scenics to stock agencies. If being in the outdoors, exposed to the elements interests you, I suggest that you research the work of some nature photographers you like and ask them how they got started. This genre of photography takes an amazing amount of dedication and is simply not suited to every camera-wielding photographer. The industry "greats" sometimes get lucky by being in the right place at the right time, but my experience with them has been that they do an incredible amount of research to see when the best seasonal dates are for a particular location. For example, when are the wildflowers in full bloom in the Blue Ridge Mountains? Sometimes these shooters will spend weeks in one area, showing up every day until they see and capture that moment when the lighting and nature combine on film for a spectacular, award-winning visual. It is very hard work, but it can be very rewarding.

Travel Photography

Travel photography is often sold as stock, but there are many professionals who make a good living at travel or travel-related photography alone. It is used in advertisements for airlines, cruise ships, hotel chains, travel agencies, and so on. It can be scenic or merely show the plane or ship as the featured product, or it can resemble lifestyle photography.

Travel photography can be a great medium for people who like to travel and photograph people and who enjoy the combination of on-location and studio lighting. Travel assignments are sometimes on-location in exotic places. Other assignments are for a very specific commercial application, such as a particular county's board of tourism. You may be asked to shoot a specific product ad or brochure, such as that for an airline, a cruise ship, a tour company, or even ads for energy companies or an environmental group.

The subjects of these images may be people dining in the ballroom of a cruise ship, a couple standing on the bow at sunset, a tropical island shot from the ship's deck, or a child in the ship's swimming pool. The images can be very traditional or documentary-like when used for editorial or educational purposes. For example, say a travel photographer is covering wine vineyards in Chile. The assignment may show the grapevines and their fruit in various stages of growth and ripeness. It may show whole hillsides of vines in the sunset. The photographer may choose to show portraits of the growers and shots of the bottling and aging facilities. The possibilities for this type of photography are endless.

Some photographers have clients who send them on trips to cover specific material or stories. They may spend one day at the location or several months. Other photographers know their client base, and they travel to self-assigned destinations knowing they will be able to sell their photography upon completion.

When photographers "bid" on an assignment to go on location for a client (meaning presenting an estimate of how much he or she will charge to do the job), they must be especially careful to research where they are going and how long they will be staying. Some bids require extensive research because the photographer must cover travel, transportation at the site, food, lodging, film, processing, assistants, guides, special needs such as canoes or boats, and any other foreseeable cost. Photographers who go on self-assigned jobs should still be savvy business people. If you go, you should track all of your expenses so that you know exactly what the trip will cost you in terms of hard costs and in terms of time. This will, in turn, let you track whether the job was worthwhile or how you should curtail expenses for your next trip.

Whether you were sent to a location by a client or you went on a self-assigned trip, your craft can overlap with stock photography. A good travel photographer usually has a balance of clients and a nice library that they either sell themselves as stock or sell through an agency.

It is worth mentioning here, too, that magazine editorial work can be very rewarding for the travel photographer who makes the right connections. You will be surprised by how many specialty magazines and publications are out there. You just need to find them and call one of their photo editors to see how you can get them to see your work. Again, this is when the salesperson in you must excel.

The Digital Age

Digital technology is the subject of a lot of big talk and hype these days in the photography world. Many people have digital cameras or camera backs in their equipment arsenals. But many photographers fear that some day they will be put out of business because of the growing trend towards point-and-shoot digital photography. All photographers and artists should be concerned about digital imagery. Why? Because digital photography is a new tool that must be mastered to stay current with our craft and trade. Digital imaging keeps getting better and better. It keeps acquiring the capacity for producing continually higher resolution images. As more systems become available, they keep getting more and more affordable.

Will all photographers be replaced one day because of this new technology? No. Only those who do not embrace it or try to understand it will lose out. Successful photography will always require the ability to visualize. It will always require a photographer who understands lighting, composition, selective focus, and camera angles. Some people feel that anything can be fixed with a computer. That is not quite true. Isn't it easier and more cost effective to be a good photographer who gets a good image to start with? Absolutely! If you start out with a bad image to manipulate versus an already well executed image to manipulate, the better image will take less time

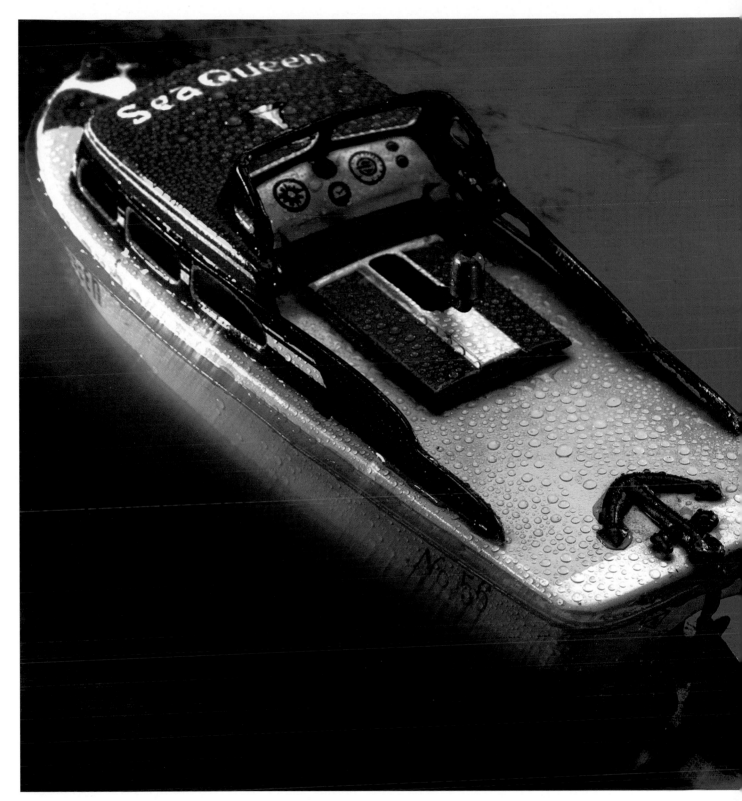

SEA QUEEN
© RICK SOUDERS.

This is an example of a digital capture that has not been manipulated on a computer.

and in the end will be a much stronger photo. Not to mention that, in most cases, it will also be less expensive to produce.

Digital photography has some really important and unique aspects. Number one, it produces instant images. With most systems, you can view your image capture on a computer monitor within a fraction of a second of the capture. It spares you the cost of Polaroids and film because you can shoot over or erase any image you don't like. You can also save directly to the computer hard drive or disk and avoid film and film processing costs.

If a client is working on a catalogue or large brochure, oftentimes the images are laid out well in advance and the image size has been predetermined. With digital-format projects, a client can save a lot of time, film, and Polaroid and processing costs. They can also save a lot of

▲ BEETLE JUICE
© RICK SOUDERS

This is an example of five separate digital shots that were combined electronically to make one image. The original individual images were a shot of the car, a shot of a straw in liquid, two shots of lemonade with ice cubes, and a sand shot.

▶ ZIMA/TABASCO
© RICK SOUDERS

This is an example of two separate photographs that have been digitally combined by a digital composite artist to create one image . The photo of the flaming Tabasco sauce was taken separately from that of the bottle of frozen Zima. Outtakes of flame from other photos were also added to the final image.

the money they would normally have spent on film scans.

Another really important new avenue for the digital photography area is the Internet and the Web. There are thousands of Web-based companies today that need to show their products online to consumers. Because the Internet is a digital medium, digital images can be quickly converted into any number of file formats, such as JPEG, TIFF, GIF, or PDF. Therefore, the Internet is a fast-growing segment for the digital market.

Digital photography can require a large up-front investment. In the long run, it is money well spent. There are some very affordable cameras that work effectively for

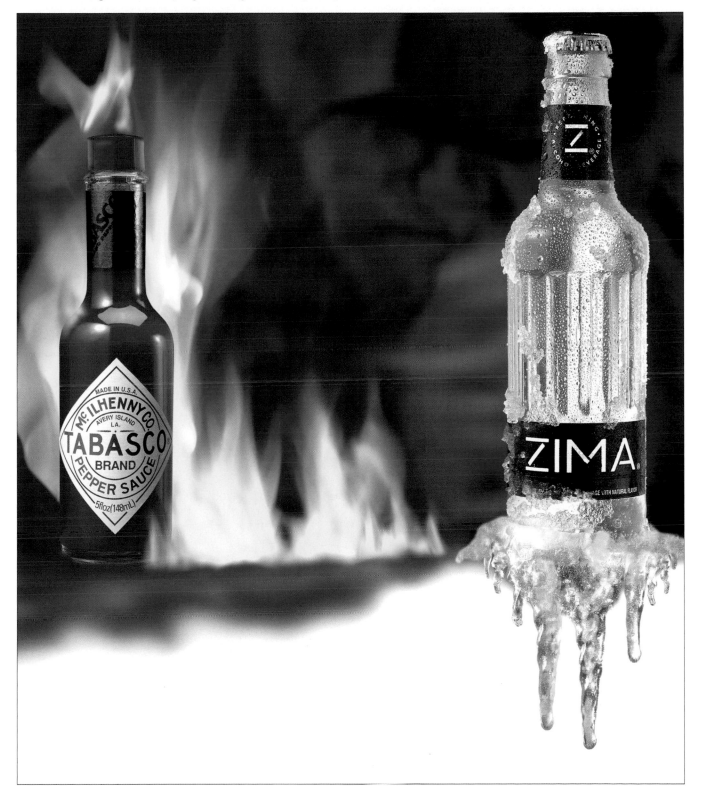

portraiture and small catalogues. The world gets smaller every day because of digital technology. It is definitely an area every photographer should be exposed to.

There are digital camera systems and backs for all photographic formats, from 35mm to 4 x 5 large format. Digital cameras capture light (or images) on an electronic chip. The electronic information that the digital chip captures is recorded in pixels. Pixels are small areas (squares) that are made up of particular colors. When you see all of the pixels together, they create a seamless image. Resolution refers to the quality of the electronic capture and its ultimate sharpness. Resolution is, to put it simply, a measure of the image's sharpness and quality. Photographers should check the technical data when buying or renting digital systems. What kind of pixel quality does it have? Is the resolution good? Can it enlarge images? How big are the capture files? The difference between a 2 megabyte and a 60 megabyte capture plays an important role in your ability to enlarge and the quality of image reproduction. The image software that a digital capture system uses is also very important. It changes instantly, so do your research.

Photographers should also understand the difference between scanning backs that require a continuous light source, such as tungsten, versus systems that require electronic strobes. With a scanning back, the subject must remain perfectly still so that it doesn't create color shifts and ghosting in the image. There are single-pass systems that require one strobe flash. There are other three-pass systems that require three strobe pops while the filter wheel changes color for each exposure, building the size of the capture file for higher resolution.

Some digital camera backs have their own proprietary software for color quality and color management. Others may require the images to be run through an application such as Adobe Photoshop. For large projects such as a catalog, digital photography can be more cost effective than traditional photography. In addition to the film and Polaroid savings, the client can save thousands of dollars in film scans. Because most digital systems either have a live video preview, allowing prop and set adjustments to be viewed immediately on screen, or a fairly quick instant preview, images can be composed and lit quickly without all of the time and cost of Polaroids or test film.

Portraits are another area of interest in digital photography. A photographer can show his client

DIGITAL FLASHLIGHTS
© RICK SOUDERS

The flashlights in this pjicture were originally photographed in the studio with a digital camera, and then digitally enhanced later using Adobe Photoshop.

MARTINI GRANDE
© RICK SOUDERS

I created this digital product illustration for use on the Internet.

captures as the shoot progresses. The photographer and client can edit as they go. Several digital portrait cameras have proofing capabilities whereby you can view an entire set of images and discard the images that you don't like. Proofs can be printed quickly and then given to the client for review. Again, pay attention to the software.

In commercial photography, clients and art directors can now give art direction from long distances. Many studios, including mine, are set up to send electronic images to a client for review. The client can review the image and email his/her comments back, or he/she can just as easily pick up the phone to discuss composition and lighting.

Keep in mind that in digital photography you can experiment with colored gels, soft focus, diffusion materials and any other special effects treatments. With digital imaging, you can see the results of your experimentation more readily and make changes accordingly. A lot of times photographers forget that they can be extremely creative with digital imaging.

Pricing of digital photography should not be as challenging as many photographers make it. It takes the same amount of photographic expertise to set up, compose and light a person, product, or scene. It really shouldn't cost less in terms of the photography or creative fee. Again, the client saves money in the film, film processing, film scans, and Polaroid expenses associated with traditional photography, and for jobs when a client has needs dozens or hundreds of shots and they are discounted by the sheer volume. Refer to the pricing discussions in the latter half of this book to further your knowledge in this ultra-important area.

DIGITAL PHOTO COMPOSITION

Photocomposition refers to the technique of combining (or altering) two or more images digitally to create a new image. Digital manipulation, digital retouching, and digital compositing describe the same kind of function, which we will refer to as photocomposition. Traditional prints can be scanned and then be manipulated and combined. Sometimes traditional film scans and digital images are combined. Because we can now retouch, distort, color, and change images with the click of a mouse, this part of the digital era is getting more competitive and more creative every day. (See examples of digitally composited photographs on pages 110–115.)

Digital photocomposition is a science and an art combined. It combines the very technical aspects of digital imaging and electronic image captures with the skill of the artist sitting at the computer. There are hundreds of thousands of jobs within photography firms, advertising agency and design firms, and magazines and corporations that employ people to digitally enhance and manipulate imagery. It takes a creative mind and eye to be really good at this. The artist must understand color, lighting, perspective, depth, and so on. One of the most popular applications for manipulating, combining, and retouching imagery is Adobe Photoshop. I recommend that every photographer at least attempt to learn the basics of this kind of software. It is important for a number of reasons. One is that you can go in and retouch simple blemishes and imperfections in your photographs before passing them on to your client. Another reason is that in the commercial photography realm, a client or art director may bring you a layout that involves the need to blend images. If you are going to be successful at shooting these images, you must understand how they get combined. A third reason relates to the marketing aspects of your business, which this book discusses in depth in the final chapters. Keep in mind that if you have a working knowledge of Adobe Photoshop or its counterparts, you can use it to produce portfolio samples, printed promotional materials, and more.

Another option in photocomposition is for a good photographer to team up with a good artist who is very talented in compositing digital imagery. As a team, you are more likely to become a much more valuable resource to your clients.

Digital technology is here to stay. It is bringing the world visually closer together every day. It is a key ingredient in the learning curve of any successful photographer, and it should be regarded as a creative tool in every photographer's mix of equipment. Digital photography takes vision, creative thinking, good solid photographic skills, and all the other essential elements that currently reside in the realm of traditional photography. The image is filmless—it exists in an electronic state. It is fast, and therefore valuable in a world that sometimes tries to defy the speed of light. And it can be a very lucrative and artistic skill for the person who indulges in photocomposition.

BUBBLING CAULDRON
© JOHN WOOD, WOOD
PHOTOGRAPHY

This image required taking four separate shots: one of the cauldron, one of the bubbling liquid and smoke, and one of the stick. Those images were then merged in Adobe PhotoShop to create what looks like a relatively simple, all-in-one-shot individual photograph. The beauty (and challenge) of photocomposition is that you can use it to engineer arresting images like this that do not look artificial or manipulated.

Do You Mean Business?

If you feel like you have mastered lighting, composition, color, and camera angle, here's a surprise for you: you have now mastered about 20 percent of the skills you need to be a successful commercial photographer.

Only 20 percent of commercial photography is about taking beautiful or pretty pictures. The other 80 percent is about the business. Success is about presentation, pricing, selling yourself, advertising, ethics, and attitude. In other words, you now know something about the *art* of commercial photography; now you'll be plunged into learning about the attitude you need to have to really master the *business* of commercial photography.

Why Are Business Skills Paramount?

Answer this one yourself using past experiences to guide you. Why didn't you like the waiter at the restaurant? Was he slow or maybe a little rude? How about that gas station attendant; do you find his negative attitude really annoying? Was the lady at the bank irritating because the whole time she was talking to you she was chewing gum and smacking her lips? Are you starting to get the picture here?

There is undeniable truth in the old warning that "you only have one chance to make a first impression." First impressions are drawn from the way you dress, the way you present yourself, the way you present your work, and your attitude about the whole package you are presenting. People can tell a lot about you by the way you tend to your grooming and appearance. This doesn't mean you have to wear suits and ties to client presentations; I don't. Yes, you need to wear clean, appropriate clothes and be well groomed, but you don't have to completely alter the way you look just to impress someone. Sell the real you!

Communications—Get It in Writing

We've talked about first impressions and appearance. Now let's discuss communications, pricing, ethics, and the art of negotiation. When you are in the business of providing a service to your clients, you need to be very clear about what they are getting for the fee they are paying.

I will discuss estimating and pricing first. Getting your agreement in writing is a very critical step. Never rely only on verbal agreements with clients about what you are shooting, how many shots you'll take, or what camera format you will use. Get these details from the client when preparing a cost estimate and then review the cost estimate with your client. I can't over-stress the fact that you should not agree to shoot anything without a client-approval signature on your cost estimate. You can get burned and end up with either very slow payment or none at all.

This is an appropriate place to also stress terms and conditions that apply to your estimates. You must establish your business practices and policies and have

GETTING THE JOB

The process of being awarded a job from a client or agency has four stages. The four stages I feel are key to getting and completing a job are as follows:

- Selling yourself and convincing the client you are the right photographer for the job.

- Providing the client with a cost estimate based on your discussions about the project's parameters.

- Revising the cost estimate (if necessary) and obtaining a signed approval.

- Scheduling and completing the photo-shoot within the limits of your budget and on time.

IMAGE IS IMPORTANT
© TREVOR MOORE

YOUR LOGO HERE

Terms and Conditions

(1) Photograph(s) means all material furnished by Photographer hereunder, whether transparencies, negatives, prints or otherwise.

(2) Except as otherwise specifically provided herein, all photographs remain the property of Photographer, and all rights therein are reserved to Photographer. Any additional uses require the prior written agreement of Photographer on terms to be negotiated. Unless otherwise provided herein, any grant of rights is limited to one (1) year from the date hereof for the territory of the United States.

(3) Client assumes insurer's liability (a) to indemnify Photographer for loss, damage, or misuse of any photographs, and (b) to return all photographs prepaid, fully insured, safe and undamaged, by bonded messenger, air freight, or registered mail, within thirty (30) days after the first use thereof as provided herein, but in all events (whether published or unpublished) within 120 days after the date hereof. Client will supply Photographer with two free copies of each use of the photographs.

(4) Reimbursement by Client for loss or damage of each original transparency shall be in the amount of $1500, or such other amount set forth next to said item on the front hereof. Reimbursement by Client for loss or damage of each other item shall be in the amount set forth next to said item on the front hereof. Photographer and Client agree that said amount represents the fair and reasonable value of such item, and that Photographer would not sell all rights to such item for less than said amount.

(5) Client will indemnify and defend Photographer against all claims, liability, damage, costs, and expenses, including reasonable legal fees and expenses, arising out of the use of any photographs for which no release was furnished by Photographer, or which are altered by Client. Unless so furnished, no release exists.

(6) All expense estimates are subject to normal trade variance of 10%.

(7) Time is of the essence for receipt of payment and return of photographs. No rights are granted until timely payment is made.

(8) Client may not assign or transfer this agreement or any rights granted hereunder. This agreement binds Client and its advertising agency hereunder. Client and its advertising agency hereunder are jointly and severely liable for the performance of all of its payment and other obligations hereunder. No waiver of any terms is binding unless set forth in writing and signed by the parties. However, the invoice may reflect, and Client is bound by, oral authorizations for fees or expenses which could not be confirmed in writing because of immediate proximity of shooting.

(9) Any dispute regarding this agreement shall be arbitrated in _____ under rules of the American Arbitration Association and the laws of _____. Judgment on the arbitration award may be entered in any court having jurisdiction. Any dispute involving the limit of small claims court or less may be submitted without arbitration to any court having jurisdiction thereof. Client shall pay all arbitration and court costs, reasonable legal fees and expenses, and legal interest on any award or judgment in favor of Photographer.

(10) This agreement incorporates by reference Article 2 of the Uniform Commercial Code and the Copyright Law of 1976, as amended.

(11) Cancellations and postponements: Client is responsible for the payment of all expenses incurred up to the time of the cancellation, plus 50% of Photographer's fee. If notice of cancellation is given less than two (2) business days before the shoot date, Client will be charged 100% fee. Weather postponements: Unless otherwise agreed, client will be charged 50% fee if postponement is due to weather conditions.

(12) In the event a shoot extends beyond eight (8) consecutive hours, Photographer may charge for such excess time of assistants and freelance staff at the rate of one-and-one-half their hourly rates.

(13) Reshoots: (a) Client will be charged 100% fee and expenses for any reshoot required by Client. (b) For any reshoot required because of an act of God or the fault of a third party, Photographer will charge no additional fee and Client will pay all expenses.

RIGHTS GRANTED:
One-time, nonexclusive rights to the photographs listed below, solely for the uses and specifications indicated, and limited to the individual edition, volume, series, show, event, or the like, contemplated for this specific transaction, unless otherwise indicated in writing.

them attached to your estimate. These terms and conditions cover such items as lost images, cancellation fees, and how legal disputes will be settled. See the sample Terms and Conditions form included here.

Now, let's go back to estimating the cost for a client project. Let's start by discussing meeting a client to review a project. You can either meet in person or over the phone. During the meeting, you need to get enough information to complete your project cost-estimate form. Always have a blank cost-estimate form handy so that you can review and make notes. I'll show you a sample later in this chapter. In the meantime, the following estimating checklist has some basic questions for which you will need answers before preparing a cost estimate:

PROJECT ESTIMATION STEPS

1. BRIEF DESCRIPTION—Get a brief description of the project to make sure it is something you want to do. Sometimes clients might ask you to do something out of your league or that you are not interested in. Be honest and stop them politely right here if you aren't the right person for the job.

2. TIMING—If you're interested, next find out how quickly the photo shoot needs to happen. It's a terrible waste of time to spend 30 minutes with a client and then find out that you aren't available the day/s they need you.

3. LAYOUTS—Always ask if there are layouts or sketches of the shot/s you are bidding on. This gets you much closer to answering and understanding the client's needs.

4. QUESTIONS—This is the time to ask all the pertinent questions you can about what you are being asked to bid on.

The following is a list of sample questions that you can refine and tailor to your own needs and your own types of projects. Use it as a starting point to get you thinking about other appropriate questions.

PROJECT ESTIMATION SAMPLE QUESTIONS

1. What camera format are they expecting to see? You can make suggestions here about the format you would recommend.

2. How many shots are involved in the photo shoot?

3. Is the client providing the product, or do you have to arrange to get it?

4. Are there models or people involved, and is the client expecting you to locate the talent? If so, get all of the "looks" information such as male or female, age range, hair color, hair length, body type, ethnicity, athletic ability, and so forth.

5. What is the surface or background against which you will be shooting ?

6. Will you need to find special props or wardrobe for this assignment, and is the client willing to let you engage in the services of a professional stylist?

7. Discuss the look and feel of the mood and lighting to see if you need to get any special equipment.

8. Will you need to hire a photo assistant or two to help you out?

9. How much time do you think this will take? After talking through some of the details, let the client know if this is a one-day or multiple day project.

10. If you are going on location, do you need to get permits to shoot? In parks or national forest areas, and on public beaches, for instance, you must check on permit prices and requirements.

11. If travel is involved, allow for mileage or gas costs. If you are flying, include airfare, lodging, hotels, meals, parking and even give yourself some kind of compensation for the travel time. After all, you can't shoot for someone else during your travel time.

12. Do you think you will be shooting all day? If so, plan on food. Everyone needs to eat.

13. Are there any other special needs or parameters for this shot?

14. And finally don't forget to estimate couriers, delivery services for film, and costs to deliver final images to your client.

15. Know exactly how quickly you need to get the estimate back to your client.

These are a only few factors to consider when estimating a job. Think about the total assignment and plan for

everything you think you will need. Include the number of rolls or sheets of film, Polaroid packs, and processing and studio supplies. The following is a sample cost estimate with generic categories. All the categories are spelled out and tallied at the bottom. The estimate should always have the client, contact, project name, date, description of what you are providing, with all costs totaled. Stipulate the usage to which the client can put your work once purchased (see p. 128 and p. 130 for more on usage rights).

An estimate form may be revised several times if the client adds or subtracts shots or other necessary items such as backgrounds, props, and so forth. Once you have the agreed upon details and the estimate is satisfactory to your client, get a signature and a due date. Also fax them a confirmation that they have you scheduled for that particular time so you have it on your calendar and they do too. If the client should need to cancel a photography assignment, consider your "cancellation policy." One standard method of charging for cancellations is to bill the client 100 percent of the creative fee plus any expenses incurred if they cancel within 24 hours of the shoot. If they cancel within 48 hours of the shoot, then you can legally charge them somewhere between 100 and 50 percent of the creative fee plus expenses. Once you have their signature and approval, you may bill them for any materials and items purchased if they cancel.

THE ART OF BUSINESS PAPERWORK
© JOHN WOOD, WOOD PHOTOGRAPHY

YOUR LOGO HERE

PHOTOGRAPHY ESTIMATE/AGREEMENT
Good for 30 Days From Submission Date
123 Uptown Avenue, Your State, 80000
Studio 222-222-2222, Fax 222-222-2223

CLIENT/PRODUCT:

DATE SUBMITTED:

PROJECT TITLE:

CLIENT CONTACT:

APPROVAL SIGNATURE:

DATE:

Project Description:

STUDIO FEES	_____	Vendor FEES (STYLISTS/SETS/PROPS)	_____
FILM & PHOTO SUPPLIES	_____	TALENT FEES	_____
LOCATION COSTS	_____	TRAVEL COSTS	_____
RENTALS & EQUIPMENT	_____	SHIPPING/DELIVERY/OTHER	_____

TOTAL PHOTOGRAPHY ESTIMATE: _____

USAGE INCLUDED IN STUDIO FEES:

Usage Rights Granted Upon Payment In Full.
This estimate is subject to a standard trade variance of 10%.

Additional Project Notes:

Primary Business Address
Your Address Line 2
Your Address Line 3
Your Address Line 4

Phone: 555-555-5555
Fax: 555-555-5555
Email: xyz.photo.com

PHOTOGRAPHY ESTIMATE/AGREEMENT

Client Information	Estimate Approval
Client Contact	Client Signature
Project Name	Print Name
Art Director	Date
Date of Bid	

PROJECT INFORMATION:

CREATIVE FEE	SET BUILDER
USAGE FEE	PROP STYLIST
ASSISTANT FEES	WARDROBE STYLIST
	MAKE-UP/HAIR
FILM/PROCESSING	FOOD STYLIST
POLAROID	PRODUCTION MANAGER
DIGITAL SUPPLIES	PROPS/WARDROBE
STUDIO SUPPLIES	TALENT CASTING
	TALENT FEES
LOCATION FEES	
SCOUT FEES	TRAVEL/AIRFARE
RENTALS	HOTELS/MEALS
EQUIPMENT	RENTAL CAR
MEALS	TRAVEL INCIDENTALS
MILEAGE	
	COURIER/SHIPPING
WEATHER DAY	MISC/OTHER

ESTIMATE TOTAL: _____

USAGE RIGHTS GRANTED:

- Usage granted upon payment in full.
- 10% Trade Variance Applies to This Estimate.
- Payment Terms Net 30 Days.

FROZEN ASSETS
© RICK SOUDERS

Calculating Your Fee

Pricing is always a volatile issue because, as hard as many organizations have tried to standardize pricing, many variables still come into play. For example, the usage of the photography, the experience of the photographer, the notoriety of the photographer, the complex nature of certain specialties, the photographer's overhead, and even different approaches to solving the visual assignment.

Make yourself a budget. Know your costs for studio rental, electricity, office and computer supplies, gas, water, telephones, and advertising. Knowing how much you need to spend on each can be difficult at first, but you can estimate a budget and then check it monthly or quarterly to see if you need to make adjustments here and there. Never look at a photo shoot and say, my fee was $2,000, so I just pocketed two grand. If all of the items in your budget come to $6,000, you still need another $4,000 just to break even. Budgeting is a critical element in running a photography business, but only about 25 percent of all photographers take the time to do it. If you don't, you have no clue whether you are making a profit or whether you are spending too much in a particular category. It is just plain stupid not to budget and keep track of your overhead!

There is no magic formula for pricing, but there are some common-sense guidelines you can use. A photographer should always know what his work and time are worth. Someone just starting out has a lower market value than a well known, established shooter, whose reputation and experience allow his fee to be much higher. In my studio, the motto is "Work smarter, not harder." Some photographers use what we refer to as a "day rate" pricing system. This is appropriate for some photographers, and is often used in editorial photography, but I am going to emphasize the "project rate" pricing system.

Basically a day rate is the money a photographer feels is a worthwhile creative fee for shooting for a full day in the studio (roughly eight or nine hours). Some photographers charge as little as $800 a day plus expenses, while others charge $5,000 or $6,000 a day plus expenses. Famous photographers can command $40,000 for a shot.

The project rate system does not set a standard per-day creative fee. Instead, with this approach, you look at the total job, its complexity, the amount of expertise it requires, and the approximate amount of time it will take to shoot. This pricing structure gives the photographer much more flexibility in setting the creative fee. For example, the photographer gets to determine the number of shots that can be done in a day and determine the value placed upon these shots. A simple product shot on white background paper or a seamless background may not be as complicated or difficult as styling and shooting a hamburger and fries. Let's say your day rate was $1,500 and your half-day rate is $1,000. You are charging $1,000 (half day) plus expenses to shoot one product for a client. Now let's say the client adds two more similar products, and you don't really have to tweak the lighting too much. You feel you can still get this shot in a day. However, you are now charging a $1,500 (day rate) creative fee for three shots. That's a great deal for the client or agency, but not such a great deal for you.

Now let's look at the same product shot on white seamless with the project rate approach. You may determine that this shot will take you between two and three hours, and maybe you come up with the same $1,000 creative fee (for a half day). Now the client says, "I have two more similar products to add, what will that cost me?" Logic says that if one product shot is worth $1,000, then three product shots should be worth more than $1,500. Because part of the total time shooting takes involves the initial setting up and testing of the lights and banging out a couple of Polaroids, you know the added two shots will take less time. Will the client pay you $3,000 for the three shots? Well, they may or may not. If you figure that they will take an additional hour or two, you can decide to charge another $500 for each of the two additional shots. Now your creative fee is $2,000. Do you see what is happening here? If you talked the client into the first day-rate scenario and bumped the price from a half day to the full day rate, you are only at $1,500. That is assuming the client won't push you to stick to the half day originally promised, in which case you would have made $1,000 less. With the project-rate scenario, you are estimating based on the time plus number of shots, but you are getting more than the full day rate from the first scenario. This is an oversimplification of what I mean when I say, "Work smarter, not harder." But as you can see, $500 here and $1,000 there adds up quickly.

When establishing a project-rate pricing scheme, you have the ability to take a look at who the client is and what the project is all about. A small local client will have

SAMPLE BUDGET CATEGORIES

Account Type	Monthly Payment	Creditor
Rent/Mortgage		
Vehicle		
Trash Removal		
Security		
Utilities		
Telephone		
Telephone		
Telephone-Wireless		
Telephone-Wireless		
Telephone-VoiceMail		
Internet		
Internet		
Cable TV		
Insurance - Employees		
Insurance - Comp/Property		
Accounting		
Legal		
Office Supplies		
Office Stationary		
Equipment Lease		
Studio Supplies		
Courier		
Shipping		
Advertising/Postage		
Equipment Repairs		
Entertainment		
Auto Expenses - Gas		
Auto Expenses - Other		
Contributions		
Subscriptions		
Dues/Memberships		
Miscellaneous		
Salary - Officer		
Salary - Employees		
Rep Commissions		
Bank Monthly 941		
Property Tax		
Total Monthly		
Income from Supplies		
Vendor Income		
Total Add'l Income		
NEW TOTAL		

a much smaller budget than a national or Fortune 500 company will. That doesn't give you free rein to gouge the national clients, but it does give you price equity because their products are sold and produced on a much more massive scale. The value of your services should increase because the sale of their products, as a result of your photography, will proportionally be much higher. Because all marketplaces vary, it is not wise for this book to establish and publish any suggested rates. Creative fees in a small-town market are sometimes less than those in major metropolitan cities such as New York, Chicago, or Los Angeles. Having said that, if you live in a small-to-medium size market and are selling yourself to clients in these large cities, your prices should definitely increase. For example, pricing in a city like Denver should roughly represent a cross section of photographers who use the day-rate system and those that use the project-rate system.

The current average daily creative fee falls in the neighborhood of $1,200 to $2,500. This same work in New York would easily fall in the $3,000 to $6,000 range.

Now before you all call or write and say "I make way less or way more than your figures," just remember that these are samples based on my research only, and they are illustrated here to show the difference in pricing scale from city to city. My research indicates that project-rate pricing (for a one or two shot still life) for our local market varies from about $1,500 to $2,500 and from about $2,500 to $5,000 for work produced for other major cities. That is not to say that I haven't shot an occasional $800 shot or a $18,000 shot.

There are some great books that discuss pricing extensively; I suggest that you do a lot of research and talk with other photographers about their billing practices to create a perfect formula for yourself. Associations like

USAGE AND RIGHTS

When pricing, you should always determine the usage rights a client is receiving. The usage rights grant a length of time for which the client may use the work. Here is a simplistic list of some possible usage rights scenarios to familiarize you with the range:

One-Year National Point of Sale (P.O.S.)	One-Year Regional P.O.S
Six-Month National P.O.S.	Six-Month Regional P.O.S
Three-Month National P.O.S.	Three-Month Regional P.O.S.
One-Year Billboard Only National	One-Year Billboard Only Regional
One-Time Magazine Cover	One-Time Editorial Feature
One-Year Trade Publication Only	One-Time Test Market

There are literally countless variations and additions to this list, and some very specialized usages are related to the Internet and so forth. Some photographers will account for their usage in their creative fee for the first time rights. Other photographers will have a second line-item on their estimate form called "usage fee." Either way works as long as you are compensating yourself. Usage varies depending on:

• the number of printed pieces upon which an image is used.

• the number of pieces using the image that are published.

• the length of time the ad or photo will run.

• the geographic regions where the images are going to appear (local, regional, national, or international).

THE ART OF MAKING MONEY
© RICK SOUDERS

the American Society of Media Photographers (ASMP) have extensive publications on these topics.

Another usage issue is unlimited time with unlimited usage. If a client wants to use an image for an indefinite time frame for any type of publication or ad they produce, you should be compensated. Some photographers bill usage as a percentage of their creative fee. In the case of unlimited usage with unlimited time rights, many photographers double their creative fee or multiply by as much as four times depending on the image and the client. When negotiating usage rights, always spell them out clearly on the estimating form. If the client wants exclusive rights, that is different (and worth more) than if the client wants one-year rights when you then can resell the image via stock agencies.

Usage rights are different from a copyright. I don't suggest signing over your copyright to a particular company. If you sell them the image and assign them the copyright, you have now permanently given away the image and you have no further legal rights to it. If you sell an image and assign the copyright, the transaction had better be worth your while.

It is imperative that you think of pricing as a make-or-break situation. If you introduce yourself to a market and price yourself low to get new clients, and you start making money, be aware of what you are really doing. You are establishing your creative worth in that market. If you are too low, you will establish a reputation as the "cheap shooter or budget shooter." You will then probably be passed up for lucrative jobs, which will go to more expensive photographers who are perceived as being better than you are. You are also undercutting your competition, and it is only a matter of time before they discover what you are doing. Alienating yourself from your peers and getting a rap as the "budget shooter" are two things that are almost poisonous. You should always keep your eyes and ears open and compare your business practices to those of other photographers you feel are of your caliber.

Let's discuss a few other cost estimating issues so that you cover everything on your estimate. It is standard for photographers to mark up studio supplies, film, Polaroid, and processing. In my research, I have found that an average markup is between 20 and 50 percent. Some professionals charge a 100 percent mark-up on film and processing. Many larger studios have a markup for handling talent, stylists, and modeling agencies. Figure out the right formula for you.

I have had photographers tell me "I don't feel right about marking up my supplies." My reply is "Fine, no one is forcing you to." You must continually receive, stock, and reorder film and supplies. That takes time, and your time had better be worth money or you are in the wrong industry. Besides, many advertising agencies (and design firms) mark up a photographer's fee by 50 to 100 percent.

Always get an estimate from outside vendors such as makeup stylists, prop stylists, assistant's rates, and food stylists. You will need to cover these items in your bid. If you don't, the client won't want to pay, but you'd better believe the vendors will want to be paid for their time. All these costs can make a successful project profitable or, if estimated incorrectly, a complete bust.

I encourage all photographers to include the following two critical statements in their estimating forms:

"This estimate is subject to a standard trade variance of 10 percent."

"No usage rights are granted until payment is made in full."

The first statement gives you the ability to account for unknown costs or changes to your budget. The second protects you from a client being delinquent on or simply not paying a bill.

Client Ethics

Client ethics simply means how to conduct good business. Treat your client the way you want to be treated, even if they don't reciprocate. If you are going to fax them an estimate within 30 minutes, get it done or call with an explanation for the delay. If you are going to follow up with the client on particular parts of the job, don't drop the ball. If you have to cancel an appointment, give your client as much notice as possible. Remember, other photographers are eager to steal your clients. If you offer great customer service and give the client a reason to like you, it is much more difficult for someone to steal them. If you lose a client, and you will lose plenty, it is important to take the time to understand why. Was it poor quality, price, poor communication, a lack of attention to the client's needs, all of the above, or something out of your control?

It is also important to be careful about what you say around and to clients. Never badmouth your competition.

It gets you nowhere and makes you appear to be making excuses about your own shortcomings. If you are that much better than your competition, it should be obvious to you and your clients without your having to make a big deal about it. Be positive, and if a shoot becomes difficult or challenging, don't complain about it. You'll have plenty of time to reflect once the client is gone. If you have high standards and ethical practices, your peers and clients alike will respect them. You will feel far more rewarded by this kind of attitude!

If your client wants you to try something you know will make a photograph look ridiculous, don't challenge them on it and say, "No, that won't work." Explain their options to them, suggest why the route you want to take is a better possible solution. If you still can't sway them, then quickly move in their direction and show them why the idea they had in mind won't work. Then you are not saying "No." You are offering to show them their idea visually, which in turn helps them understand that the idea wasn't going to work. This is critically important because you thereby make your client a part of the decision-making process. Also, you don't sound like you are another stubborn, egotistical photographer!

Having said all this, there is one time when you should absolutely say "No," albeit in a very polite way. If a client wants you to do something unethical or that violates your practices, professionally excuse yourself from the assignment or the bidding process. If you simply don't want to bid with a particular client, either be booked during the time they need you or estimate the project on the high side. That way, you are not likely to get the work, and you aren't blatantly saying "No."

If it seems as though there is a lot of game-playing involved here, think again. This is business. Client relationships are all about strategy and communication. In business, you cannot take transactions personally. You must evaluate them and any conversations regarding them from a purely professional point of view. This makes the creative end of the business much more fun. Always try to be polite and remember who is footing the bill. Clearly state what you intend to perform for a client. Clearly and accurately state the price you intend to charge. Clearly state what the granted usage rights are and the specific length of time to which they apply. If your communications are accurate on the front end, you will find the creative work much more relaxing and fun. Always keep what you are doing creative and enjoyable!

NEVER SAY NO

"Never say no" is another phrase that separates the true professionals from industry "hacks." If a client or agency asks you for a certain look, lighting style, or compositional arrangement, lend an honest ear. If you say, "No, I can't do this," it comes across as "I don't want to do this." Don't position yourself as part of the problem; position yourself as part of the solution. This creates a win-win situation, making you look professional and offering the client solutions.

For example, you might bid a job and have the client say, "Well, I know we talked about this style of lighting, but I changed my mind, and I really want this look instead." This can be frustrating because it throws off your entire creative visual thought-process. You could be stubborn and say, "No. This is what you asked for, this is what I bid, and this is what I'm shooting." But then you'll probably never see that client again. Try a more creative and friendly approach. You can tell them that you would be happy to switch the lighting and go in a different direction. At that same time you can remind them that this will take a little time (or a lot, depending on the changes) and you are concerned about the extra time and going over their budget. That offers them an option and the power to make a decision.

The Art of Selling

One of the most important strategies in business is the art of selling. Superior visualization and photography skills will not get you even a quarter of the way to success without good communication and presentation skills and the ability to sell yourself. (Some photographers may disagree about this, but I say look around and pay attention to who is successful and why.) Incredible photographers who also have incredible sales skills are highly successful. It is also true, however, that truly great salespeople with marginal photography skills can succeed and have far more lucrative careers than superb photographers with poor sales skills.

Portfolios and Presentations

One of the key elements in the art of selling is your presentation style. Remember that as a photographer, you have to keep three things in mind when designing a presentation or a portfolio:

1. You must have a great presentation that can be delivered in person.

2. You must have a great presentation that can be dropped off and viewed with no interaction between you and the client.

3. You must have a strong enough presentation that a third party, such as a photography rep, can use to present and sell your work on your behalf.

It is not practical to design three different portfolios for these different scenarios, so when you are designing your presentation, make sure you have a body of work that fits the criteria of all three.

What is a professional presentation? I'll answer that question by giving some examples of clearly unprofessional presentations. Believe me, I've seen them all. A few examples of poorly presented materials follow.

There are pros and cons for every style of presentation. You have to decipher what works best for you. For example, nothing beats the true, rich color of transparencies. The drawback to using them, however, might be the way the client views them. Are they presented on a color-correct lightbox, or are they being held up to fluorescent or window lights? Print books may not be able to match the vibrancy of transparencies, but they can come in a close second if you make them correctly.

Print books are unbeatable in terms of their viewability under a variety of lighting situations. Portfolio books are easier to hold, look through, and transport than preentation boards held in a case. Ease of viewing is a major concern for some clients. Also keep in mind that it is easier sometimes to switch images in a book than to mount and cut new presentation boards for transparencies.

What about creating your portfolio on CD-ROM? If you have someone producing your CD who knows what he/she is doing, this is a great idea. The key is to make the CD easy to plug in and play. Another important

WAYS NOT TO PRESENT

- A box of loose 35mm slides that are not set in pages or presentation boards.

- Loose 4 x 5 film that has not been put into any kind of presentation format.

- Transparency boards upon the back side of which the images have been taped. No attempt has been made to cover the back to hide the tape.

- Transparency or print boards that are dirty and/or dog-eared.

- Loose prints that are covered with fingerprints.

- Boards of different colors and sizes that don't relate to each other.

- A print book with dirty print sleeves.

- Materials that have not been cleaned prior to showing.

In all of these examples, you see that not enough time and respect went into creating these presentations. A photographer is usually trying to sell him/herself to creative people or clients buying a creative product. Remember this, and try to present your work in the best possible format. Cleanliness of your materials cannot be overemphasized.

consideration is that the images load quickly with little work required to navigate the CD. Your specific clientele must be sophisticated enough to have and use CDs in their computers. Keep that in mind.

Web sites are great and are being used more and more. The key to a Web site is getting the word out, making sure the images load quickly, and always offering clients a way to contact you electronically.

Business cards and other leave-behind materials are also important elements of presentation. Your clients need images and contact information for future reference. *Do not forget to provide them with some.*

THE ART OF PRESENTATION
© RICK SOUDERS

There are literally thousands of ways to show off your work. This photograph shows a few of the presentation methods we use at my studio.

Making a Strong Impression

The art of selling and presentation deals with your entire body of work and with you as a person. The way you walk into the room, greet people, start the presentation, and your overall appearance will leave a lasting impression. I'm not saying you can't be nervous, just try not to advertise it. You don't have to wear a suit and tie if that's not your style. It certainly isn't mine. What you absolutely must do is be polite, courteous, and calm. Be engaging and start the conversation.

Don't show work that is not strong or that needs excuses, and don't show work you don't like to do.

When presenting the work, let the client or art director conduct the meeting at a pace that is comfortable for them. If you are talking about each image, keep it brief. No one wants to hear a dissertation on why you like each image. You should be able to gauge whether you are speaking too much or not enough. Another important tip is to ask clients questions. This engages them and keeps them interested in the presentation. It also makes them participate in your presentation, and suddenly they feel a little more comfortable. Always leave them with a way to contact you. Either leave business cards or printed promotional pieces. I personally recommend both. Don't forget to leave them with a call-to-action. Ask if projects are coming up that you can bid on. Mention that you will call in a month to follow up. Whatever you say, leave yourself an opportunity (or excuse, if you will) to call on them again.

Your portfolio or body of work says a lot about you. You must engineer a portfolio that does two things. First, it must show your particular photography skills. Second, it must show what kind of photography you like to do. Never forget these two points. Don't show work that you feel is not strong or that needs excuses, and don't show examples of work that you don't like to do.

These are simple principles, and you might say, "I would never do that." The fact of the matter is that over half of all photographers show work in their presentations they don't even enjoy doing. I think this is a huge mistake. If you have a couple of really wonderful car shots in your book, but you hate shooting cars, then get those images out of your book. Why sell something that you don't like to create? You can argue that it is necessary to bring in money. This is a lame excuse. It is easier to sell the type of work you enjoy and the type of work you do best. Remember, this book is about making your career fulfilling and not just a means to earn a living. If you enjoy your work, then your work will be better. The more you show work that you don't enjoy, the more you will be hired to shoot that kind of photography. This becomes a vicious cycle and eventually you have a lot less time to shoot the things you like.

WAYS TO ARRANGE PORTFOLIOS

Is there such a thing as a perfect, totally professional portfolio? Yes and no. No in the sense of a list of objective criteria. For instance, you can argue over the quality of a transparency portfolio versus prints presented in a book. You can argue over the best size of prints to present. Yes, however, in the sense that there is a perfect portfolio match for you, the type of work you like, and the type of clients you are targeting.

Here are some samples of different styles of portfolio presentations. There are hundreds of variations on these, but I want to point out a few of the categories.

- 4 x 5 or 8 x 10 transparencies on 11 x 14 matte boards.
- 35mm slides in slide presentation boards that hold between 12 and 20 images.
- Printed pages bound into a book format.
- Printed pages in sleeves in a binder-type portfolio format.
- Printed samples laminated to boards with felt backing.
- Printed samples laminated to thin-gauge aluminum.
- Prints on matte boards.
- Interactive portfolios on CDs.
- Interactive portfolios on interactive business card CDs.
- Internet or Web portfolios.

Ways to Promote Yourself

Your portfolio presentation and your promotional pieces should conform to your budget restraints. Remember, this is a business venture. The sooner you tie together the costs of doing business with the creation of photography, the more successful you will be. If you are a working professional and have a lot of extra cash to toss around, then consider a custom-designed portfolio. You may also decide to have your leave-behind campaign designed by an art director or a graphic designer. If you are fresh out of school, determine what you can spend and then shop accordingly.

Let's talk about other aspects of selling yourself via leave-behind pieces, direct mail, sourcebook ads, the Internet, and other professional services. Leave-behind pieces are materials that can be shipped with your portfolio. This lets clients keep references to your work or materials that you can also use during a portfolio showing before leaving them for your potential new client.

New photographers who are trying to get work as assistants should leave a business card and a résumé. This allows a photographer or studio manager to have a resource for reference when hiring additional people. One additional step that can be a helpful addition to your résumé is a photograph. If you are applying for an assisting job or showing work at a busy studio, an attached photograph may help to leave an impression that will keep you remembered.

If you are a working photographer, whether just starting out or revamping your career, the following is a list of suggested leave-behind pieces or promotional strategies that will help you.

- Leave as many materials as the client, agency or graphic design firm thinks they will need.

- Business cards are critical, and you should always have plenty on hand.

- Leave a sample or two of your work behind.

You can either have items professionally designed and

BLACK BOOK ADS
© RICK SOUDERS

printed, or you can take advantage of today's computer technology and print your own samples on an inexpensive $300 color inkjet printer. The obvious advantage of printing your own samples is the money you'll save.

But consider this as well. Every time you go to a portfolio presentation, you can do a little research about your client. For example, what products they make, who their clients are, whether or not they have a Web site and what information it contains, etc. You can then print a sample or two that are tailored directly toward that client or agency. Because you are making a presentation, be sure to include enough samples for anyone who might be attending the show. If a certain person or art buyer was unavailable, leave a sample packet for them. Always make sure that at the very least your name and telephone number are on the pieces you leave behind.

Direct-mail campaigns with postcards or photo note-cards can be another effective way to target clients. Again, select your best work—work that reflects what you want to shoot. Then print these images as direct-

mail campaign pieces. Here again you can hire a graphic designer to make a "killer" piece, or you can print your own pieces for mailing. With an inkjet printer and inkjet photo paper you can print your own images for mailings.

You can also buy presized printable postcards and note cards. Your target market can be as small as five potential leads or it can be several hundred. It depends on whether your target is a certain city, region, industry, or specialty market. Sourcebook ads are great for medium- to long-range goals. Sourcebooks are industry specific publications that publish a collection of photographers' ads and then market and distribute these books to clients, agencies, and graphic design firms around the country and world. If you are just starting out, spending $1,800 and $4,000 for a sourcebook ad may not be within your budget. There are several books to consider. You'll want to check their rates, distribution, and requirements to get space in their publication. Some publications require prequalification before ad space is sold. The two publications that my studio uses are *The Black Book* and *Alternative Pick.* If you are not familiar

Don't Leave a Friend Out
in the Cold This Season.

meet "COLORADO"

with these types of industry publications, get busy and do a little research. They are great tools too for discovering what other photographers are shooting. You can see new trends and lighting styles. Established photographers should constantly be perusing these publications to keep abreast of what kind of work is popular and what kind of work their competition is doing. There are also regional and national client database lists you can subscribe to that cover art buyers, magazines, and so forth.

When deciding whether to run a sourcebook ad, you should get information about each book. You will be spending a lot of money, and you want to be in the correct publication for the type of work you do. I will not attempt to pigeonhole certain sourcebooks with certain market segments because many sourcebooks redesign themselves to target different markets. There are publications that target commercial product imagery and people/lifestyle. Others cater more to the entertainment industry or the annual report segments. Be very studious and get the facts before you sign up and spend the cash.

WEB ADVERTISING

Web-based advertising is a very good and effective way to reach potential clients that you may never have thought to target. By Web-based advertising, I do not mean banner ads linked to other sites. I simply mean you can design your own Web site to show off images and to provide clients with more information about you. There are software packages that help you design basic Web pages for the photographer who wants an Internet presence without spending a ton of money. The more established professional should hire a Web designer who has both great design skills and solid HTML writing skills. This is the ultimate way to go.

In our fast-paced society, a Web site is a very good way to communicate to potential customers quickly and efficiently. When designing a Web site, treat it as you would any other part of your advertising mix. Create some criteria to determine your target market, potential audience, your message (what do you shoot?), and how you can be contacted? You'll find that the Internet can be a valuable tool if you understand and use it.

In addition to your own Web site, you might consider any one of the numbers of sites that offer online portfolios. These virtual portfolio companies charge either a monthly or yearly fee, and they allow you to have your own home site within their system. You get to upload a portfolio of somewhere between nine and twenty images. You get to have information about yourself, and there is a feature where you can be directly contacted for additional information, portfolio requests, or potential jobs. These companies spend a fair amount of money advertising their sites, and most will provide you with a link from their site to yours.

I mentioned other professional services, and I don't want to exclude two important options that photographers should consider at some point in their careers. One is to use a professional photography consultation service that helps photographers in a variety of areas depending upon their specific needs. These services help photographers establish a new portfolio look, image selections, target marketing, promotional ideas, Web site development, and portfolio drop services to clients and agencies. There are some well established professionals in this arena. A consultation service can be invaluable as long as you know what you are asking of the consultant and you remain open to some very critical feedback about your business and your images.

The second professional service is that of a photography or artist representative. These are usually independent contractors whose services you contract. These "reps" will take your portfolios to new clients, act as your representative, negotiate bids with clients, help with your promotional needs, and assist in client customer service. A good photography rep is worth his/her weight in gold. There are many industry deviations to artist representative contracts, but basically a rep takes between 20 and 35 percent of the creative fee for selling to the client. They provide the estimates and follow up after the shoots. Reps usually also contribute a percentage of their business earnings toward your advertising costs. For example, if your rep gets 20 percent of your creative fees, this person would pay about 20 percent of your advertising costs. It works out to be a fair deal for both parties.

Be cautious about whom you choose to represent your work. Make sure that the rep doesn't represent other photographers who currently shoot or specialize in what you want to be doing. Make sure the rep doesn't have too many clients: you want plenty of their attention.

Most importantly, establish clear communication and develop a clear and understandable contract. The rapport between a photographer and a rep is a very critical element to the success of that photographer. Another thing to keep in mind is that when you are starting out in this business, you should represent yourself. This is important because it builds your communications skills, increases your confidence, and makes you meet new clients in person. You develop that all-important art of selling. Moreover, you can better assist a rep once or if you decide to go that route.

Following Up

The art of following up is one of the most critical lessons that you absolutely must take from this book. If you make portfolio presentations, follow up a week or so later. If you promise to call a person on a particular date, then be sure you do it. If you promise an estimate by 4:00 PM, then get it over to your client by 3:30 PM. If you have to cancel an appointment, then do so well in advance with a very legitimate reason.

Most photographers and photography assistants mistakenly think that if they make an attempt to contact a client, show their work in person, leave a business card, résumé or promotional piece behind, they've done all they need to do to yield success. They could not be more wrong. People will only remember you and your work if they get a number of opportunities to remember who you are. You might walk through a door at the right time when a client is looking for your particular style for a shot. Chances are, though, that your business card, résumé, or promotional pieces will end up in a file or sometimes even in the trash. If you don't follow up with a thank-you card, a thank-you email, or an occasional phone call asking if you can help or provide a bid, then you should find a different career. People aren't going to magically remember you as their "star" photographer or assistant.

I am always amazed at the number of photography assistants who speak with either my studio manager or me and never follow up again. We have seen some truly remarkable and talented people who we never work with. There are two basic reasons for this. The first reason was stated earlier. After several people come in to show their work, it is hard to remember names and faces, no matter how good they are. The second reason is that in a lot of cases, I need assistants or stylists right away. I am most likely to call on the folks who keep calling me. I

remember them; more importantly, I feel like they are interested in me. It's that simple.

Part of the art of selling and follow-up is knowing when and when not to say or do things. If you are annoying, you will lose your clients or potential clients every time. By annoying, I mean being someone who calls weekly. Don't beg for work. Don't say things like, "I have called you 60 times and you still haven't given me any work." Don't drop in on clients unannounced; it is rude. You should at least call to say, "I'm in your neighborhood. Do you mind if I drop by?"

Tenacity is a valuable quality because it speaks of being serious, aggressive, and self-assured. Whenever you are speaking with a client, potential client, or new lead, always give a call-to-action during the conversation. Let them know that you will follow up in a week or two. Tell them that you will send a new promo piece in two or three weeks, then follow up. Always give yourself the opportunity to follow up.

When you send a portfolio or do a portfolio presentation, follow up with a quick thank-you phone call or email. Then send a thank-you card about a week later. That equals three times you are in the client's face in a single week. It is polite. It is not annoying, but it is tenacious. Here is another trick to use with more difficult

CONTACT INFORMATION

You can direct people to your Web site in a variety of ways. This aspect of marketing is critical. The following options are places where you should include your Web address:

1. Business cards
2. Stationery
3. Voice mail
4. Leave-behind promos
5. Direct-mail promos
6. Sourcebook ads
7. Email attachments and announcements
8. Links to other sites
9. CD-ROM and Interactive cards on CD
10. Thank-you cards and notecards

clients. If they don't respond to calls during business hours, call them in the evening at their office and leave a very polite voice mail. That way they didn't have to speak to you in person, but you still had the opportunity to get yourself in their presence.

Since we have discussed portfolio presentations and their importance, this is a great opportunity to expose you to **delivery notices.** When a photographer drops off a portfolio at a design firm, agency, or client's office, there is always a slight risk that it may get lost or damaged. Industry standards dictate that original transparencies and art are valued at approximately $1,500 each. Using a delivery memo ensures that the person receiving your portfolio accepts the responsibility of taking good care of it. It is an account of everything that was sent, where it was sent, and to whom it was sent.

Don't be annoying— be tenacious

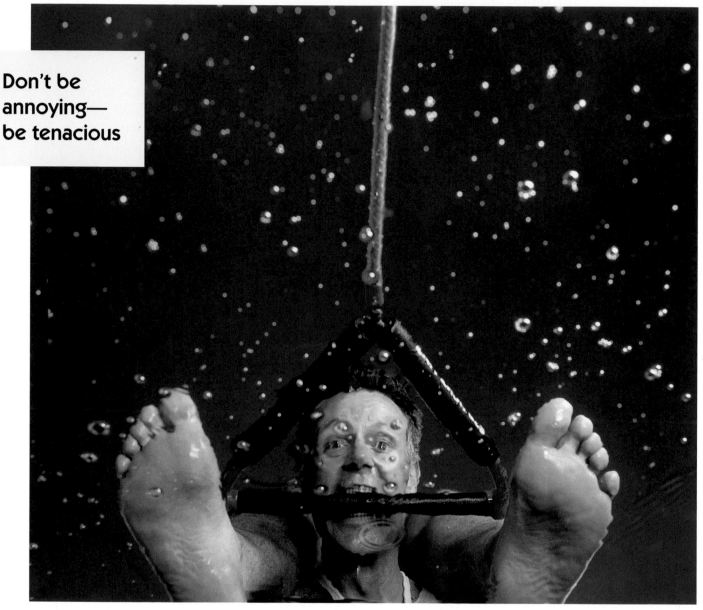

BAREFOOT WATER SKIER
© RICK SOUDERS

YOUR LOGO HERE

DELIVERY NOTICE

123 Uptown Avenue, Your State, 80000
Studio 222-222-2222, Fax 222-222-2223

Shipped to: _____ **Date:** _____

Company: _____

Address: _____

Phone: _____

The following portfolio items were sent to you. Please review all items carefully. Receipt of this delivery notice is acknowledgment of acceptance. Please review the portfolio items when returning and refer to this list. Items not returned may be billed to you. (The industry standard for missing portfolio materials is $1,500.00 per original.) Please note that none of these images can be reproduced without express authorization of the Studio. Thank you for your interest in Our Studio!

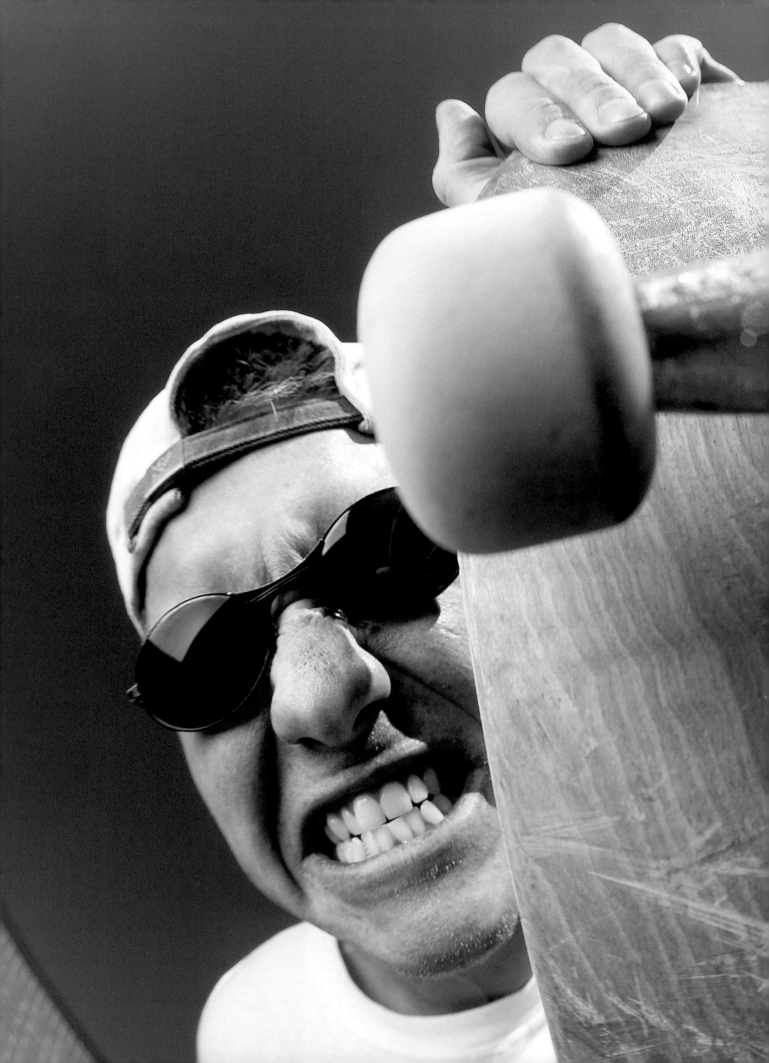

Attitude is Everything

Attitude is the essence of your personality combined with your visual capabilities and your business practices. Attitude is what you project about who you are, how you feel about yourself and your work, and the manner in which you display this disposition. Attitude is healthy. Cultivate the outgoing, energized, and positive you.

What is Attitude?

Attitude is the most critical thing that you will extract from the pages of this text. Attitude is an expression of your very heart and soul. It is the essence of who you are and how you are perceived by others. A healthy attitude will play a far-reaching role in your photography career. More than that, it will define the success of that career.

Why the emphasis on attitude? It's very simple. Attitude is about your life. It's how you wake up in the morning. It's how you visualize the world around you. Attitude is how you turn your thoughts into feelings. It is how you turn your visualizations into images. It is how you greet people. Attitude is the mood and emotion you project in a sales meeting.

A winning attitude combined with great images is the essence of the art of selling.

A healthy positive attitude will keep you excited about your work. It will give you an enhanced sense of well-being and self-confidence. It will allow you to take criticism as a business communications message and not as a personal insult. If you have a positive attitude you will be a healthier person both physically and mentally. That is a scientific fact. On a more cerebral level, you will be more open to your visual surroundings, and you'll be open to working on projects as a team. You'll simply be much more creative.

Attitude is sometimes defined as arrogance. While all people in the creative industry are arrrogant to some degree, I want to keep the discussion centered on you and your feelings, arrogance aside. The more of your self you express through your work, the more attitude you are giving your audience and your clients. The publication of this book had a lot to do with attitude. It has been said that a key ingredient to my success as a photographer was the integration of attitude in my imagery, from the way I approach my business to the way I visualize and record images on film. A lot of "me" goes into my work. I try not to just capture another image on film but to create a new visual statement. It doesn't matter whether it is a product on a simple background or a large set production. If you put your positive attitude into the photo, it will show more of your personality than if you don't.

Conviction and Perseverance

To further refine and define the attitude of commercial photography, I must discuss conviction. You can have a very positive attitude, but that still may not give you the drive to be successful. You also need conviction. You can have a great handle on your lighting and compositional skills. You may be a gifted conceptual thinker. You may even have some really awesome images stored in your mind or a couple of great marketing campaigns just waiting to be unleashed. That's great! Now what are you going to do with them? Are you a procrastinator? Will you think about these images or marketing campaigns every couple of weeks? When you have several free days that could be spent in the studio, do you decide instead to go get caught up on the latest movies? In other words, just how committed are you? It takes a lot of personal initiative to run your own photography business and to create your own images. A lot of the time you're not on an eight to five schedule. You must have the motivation to get up in the morning and finalize that great marketing idea on paper with time lines and goals to complete it. Instead of thinking about the awesome shot you need, put your thoughts on paper and make a list of props and supplies you need to accomplish the idea. Great ideas are worthless if they are never shared.

Conviction is the ingredient that organizes you. It is the ingredient that motivates you. It stimulates new thoughts and ideas, and in turn, it perpetuates a healthy attitude. Conviction deters procrastination. It inspires you to share those great ideas and to be somehow rewarded by them. No one said this wouldn't be a huge amount of work and commitment. Conviction is the commitment part. You have to want something to be successful. You have to challenge yourself daily and weekly. You need to reward yourself for this conviction. Get off your couch, put your genius marketing campaign into an outline with goals and timelines, and then go out for a movie, dinner, or drinks. We have to reward ourselves for our commitment and conviction. This in turn stimulates that healthy attitude.

Perseverance is another topic that we need to discuss. Generally, not many things are handed to us in life. We need to go after them if we really want them. It is that way in all aspects of our lives: our approach to business should be no different. If you want to be in a relationship

with someone, you have to want to be and you have to work at it. So think of perseverance as your "relationship," your marriage to your business.

You have to define what you want. You have to define what you think is realistic for you. You have to determine what about this relationship inspires you. You can't put together a brilliant portfolio and sit back and wait for something to happen. You can't send out the ultimate promotional mailing and wait for something to happen. What you have to do is methodically set short-term, medium-range, and long-term goals. They can constantly change. The point is you are defining and refining what you like, where you want to be, and what it will take to get there. There will be setbacks. Maybe you didn't get the immediate overwhelming response you wanted from the portfolio. Maybe you only got one call from that promotional mailing. Maybe the money isn't pouring in like you dreamed it would. Stick it out and hang in there. That is what perseverance is all about. Continue to review and evaluate what is working for you. Look at

ATTITUDE: FIRST AID FOR THE CREATIVE SOUL
© JOHN WOOD, WOOD PHOTOGRAPHY

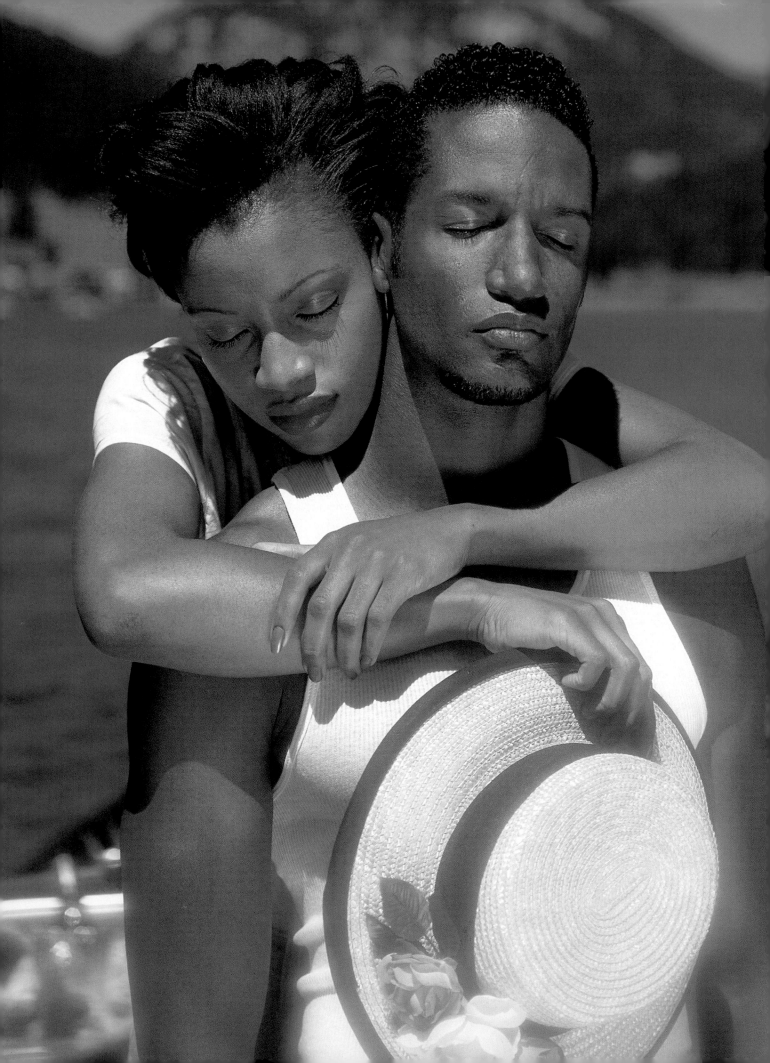

what you like and what you don't. Make changes based on these observations and continue on. If you want to be successful, you have to create a successful environment to work in. It won't just happen on its own.

Make It Happen

Whether you're making the ultimate career change, re-inventing yourself, freshly graduated from college, or assisting, a very important assessment is where you are currently. Maybe not so much where are you personally or metaphorically, but where are you physically? What city are you in? Is it right for you? Why are you there? Should you stay, or can you build a better career elsewhere? These questions are tough and hard to answer. Remember, try to balance your career wants and needs to your lifestyle. Finding a place where you want to work and live is important. Some colleagues argue this point by saying you can always start somewhere and move. This is true, but you should have some idea about whether the place is a stepping-stone or your career destination. Sure it can change; just use your brain now. Give the issue ample thought so a move isn't such a big surprise or tough change later.

Let's emphasize that where you live should somewhat coincide with the lifestyle you want. In other words, make lifestyle and location an important factor in the destination choice. It's your career, and if you are going to enjoy it you must enjoy where you are performing it.

Here is what you should do. Make a list of the places you like and that would fit your lifestyle. Do some research. Go visit these places. Check out resource books and see who the competition might be in these cities. Using the Internet, you can find out demographics, weather, population, and all kinds of other really helpful information. Talk to photographers, assistants, and photo suppliers in these markets. Determine how you might fit in or what business niches you might fill. In doing all of this research, remember one thing: wherever you go, you can make a place in that market for yourself. You have to want to live there and be committed to make it work. No one can make this decision for you. This choice is yours and yours alone.

Once you have narrowed down your search, do even more research. Go visit and check out the city. Research the agencies, design firms, vendors, and clients in the area. Plan some goals. When can you realistically afford to move? What can you do for income during that transition? What will the move cost you? These are important questions to get a handle on.

If you get your research done, you will know what photo labs to try out. You'll know where to buy film. You'll have a list of rental studios and rental equipment houses. You'll have a marketing database of potential customers. You can send out a promo letting everyone know "you have arrived." A little research and planning up front can make the difference in your attitude about your new location. With all of your goals in place, continually redefine where you are and try to stay on target. Make realistic goals and don't beat yourself up.

You can always join professional organizations like American Society of Media Photographers, Advertising Photographers of America, Art Directors Clubs, Ad Federation Clubs, American Institute of Graphic Arts, and so on. Networking is really important if you are the new person in town. You'll be surprised at what you can learn about your city and your industry when you start talking to people. You'll gain a wealth of knowledge.

Who are you—really? You have read the first six chapters on visualization, seeing, and lighting. You've reviewed all the possible types of commercial photography career options, and you're getting a handle on what you like and what inspires you. Now you know what it takes to be good with communications and business practices. The art of selling and portfolio presentation is engraved in your mind. You've learned the fine art of being tenacious.

A successful image is a precise blend of light, shadow, color, texture, and a whole lot of attitude.

COUPLE BY MOUNTAIN LAKE
© RICK SOUDERS

Perseverance in your career is like perseverance in a relationship.

That positive attitude is starting to swell and soar. Now you're researching that perfect lifestyle and that ultimate destination that you want to live out your career in. The plans are in the works. The goals are being formulated and set in motion. You have the conviction and motivation. What else is left?

You are left. You need to constantly be honest with yourself. Review what you are doing often. Evaluate whether your decisions are making you happy. Are you waking up in the morning nervous but full of life and vitality and ready to make another daily attempt at sparking a successful career? Are you being you? Don't pursue your career solely for the money, status or image. Pursue your career because that is who you are. Pursue that career you have always wanted. Pursue that career that is the essence of your visual world and your attitude. Make sure you are always happy. If you aren't, make changes. This is all about you, don't ever forget that!

FIND YOUR DESTINATION
© RICK SOUDERS

Attitude is Healthy

You may think by now that you have gone from a book on conceptual thinking to a book on business to a self-help book. All of those concepts work together. You've seen that the importance of business, communications, pricing, ethics, and the art of selling account for about 80 percent of the success of your career. Attitude is the key ingredient you should extract and keep in mind for constant future reference.

PASSION

We've discussed tenacity, conviction, and perseverance, but we haven't mentioned passion. All three of the former play an important role in developing passion, which is part of your relationship or marriage with your career. It is the spirit you can't separate from your being, the emotion that provokes or encourages you to visualize and create images. As an artist, you need to pay attention to emotions like love, rage, disgust, pain, suffering, and hope. This doesn't mean that you should let your emotions overrun your photo shoot. If you do this, you haven't been paying attention to the definition of attitude. Do, however, let your passion enter your images. Passion is what makes us unique. It gives us our own style. It helps us to communicate what's right and wrong with our world. Passion is the reason some people become photojournalists or editorial shooters. They want to tell important stories. Some people have a passion for the land and environment and become nature photographers. Some people have a passion for animals and become wildlife photographers. Some people are into trends and lifestyle, and they shoot fashion. All of these photographers are defined by a certain passion. And most importantly, all of these shooters are documenting and recording our world for future generations to observe and learn from.

You may have a passion for black-and-white or infrared imagery. You may have a passion for color and composition. It's not easy to separate your interests and passions from your artistic and professional choices. You can control your attitude and demeanor with clients, but it is hard to squelch your passion. Use it for all it is worth.

FEEL THE PASSION—
DON'T RESTRAIN YOURSELF
© RICK SOUDERS

CULTIVATING YOUR VISION

You may not always be asked to produce passionate work. You may get jobs that are boring or that don't stimulate you. You can choose whether or not to shoot them. But make sure that you create photographs and accept projects that feed your passion. You can seek out projects that do this, or you can create your own for a portfolio series. By reaching within and cultivating your vision, you are finding causes or issues that are near and dear to you. You should somehow incorporate this into your photography, even if only for yourself and not for client assignments. It will keep you fresh, satisfied, and excited about all the other projects you do. For example, if you feel strongly about a certain charitable cause, see how you can help with your visual work. Maybe you can create really dynamic photos to donate to them. These are called pro bono jobs or assignments. I try every year in my busy studio to support at least two charitable causes through my visual imagery. It is not only a good feeling to be able to help out, it is also important to feed

your interests. It can be very satisfying to make a difference visually. The photos can very well turn out to be some of your best work. Unleash yourself occasionally and see what happens.

EXPERIMENTAL OR PERSONAL PROJECTS

This is the perfect opportunity to take what you're learning in this book and stretch yourself. It is vitally important to look at things from new or unique perspectives. It makes us better photographers and people. Try new lighting equipment and new lighting techniques. Take some of the ideas in the visualization section of this book and utilize select focus, color gels, wide-angle perspectives, and so forth. Try new films. Shoot your old films and push them or learn about cross processing. Play with digital imaging and manipulation. It doesn't matter if you even like the result. What matters is that you experimented and you learned something new. Take some risks and just go for it. After all, nobody needs to see the film if you don't like it. You might surprise

DIGITAL BLOCKS
© RICK SOUDERS

I used a high resolution digital camera for this studio shot.

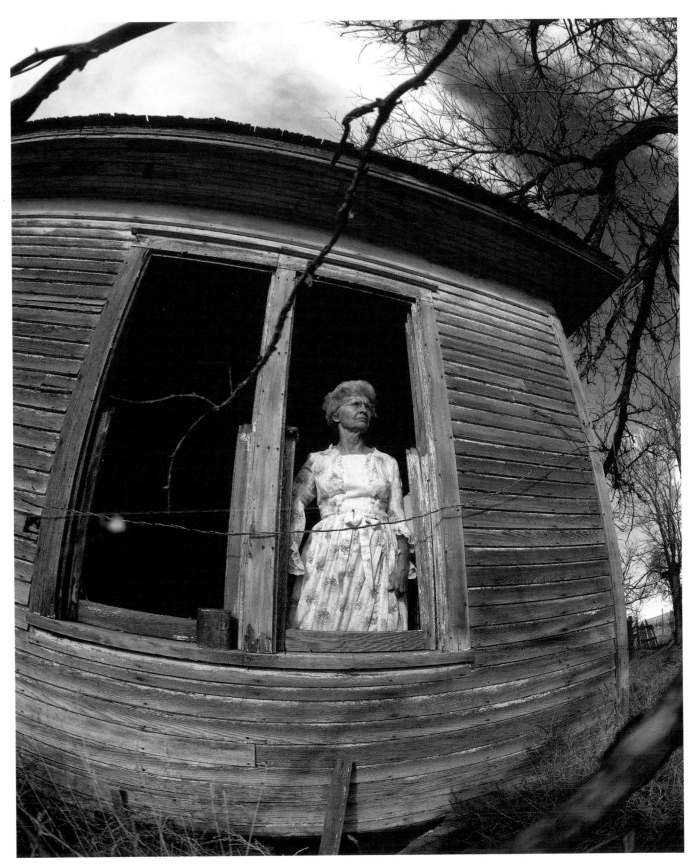

BETTY
© RICK SOUDERS

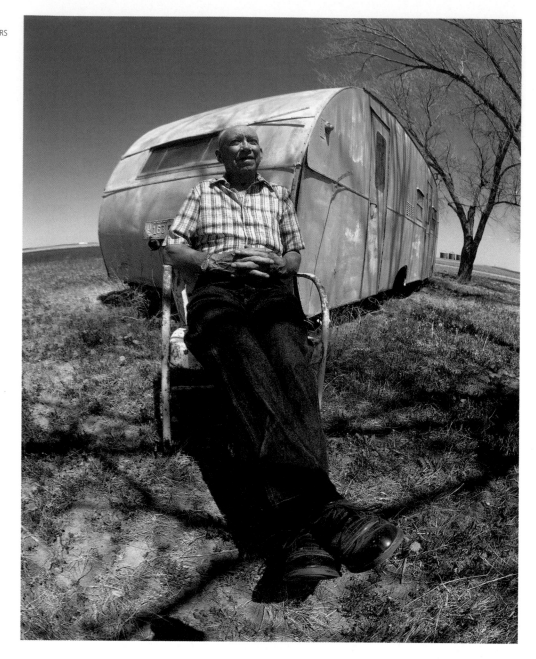

yourself though and find a new technique to add to your own personal arsenal of visual tools.

Certainly, you should try new types of photography that you think might be fun. You don't really have anything to lose and only knowledge to gain. Sure, film processing and Polaroids cost a little, but no more than what the alternative, a movie and snacks, costs when you are feeling lazy and uninspired.

Every photographer should have a body of personal work. This has nothing to do with client assignments, although many times clients will view your personal work and hire you because they like it. As a successful commercial photographer, I have a passion for seniors and

elderly people. We all grow old at some point (if we are fortunate enough to live that long). I developed a personal body of work that deals with retired seniors in a simple environment that says something about them or their lives in one encapsulated fish-eye, wide-angle shot. This has become my personal project and passion.

Personal work and experimental work go hand in hand. They let you explore new boundaries and help define who you are. They stimulate you and nourish that all-important attitude. They are satisfying and usually become an important part of your overall body of work. Whether starting out or revitalizing your interests, you must consider these options.

EXPERIENCE THE ARTS

Because in our visual world we are stimulated thousands of times per minute, successful photography must take that visual stimulus to a heightened level. Photography is one of our newer art forms. It is important for us to garner as much knowledge and wisdom as we can from all the older, more established arts. Many of them molded and influenced photography.

Painting, drawing, and illustration are all traditional art forms that convey lighting, color, texture, shape, and form. Take yourself out to gallery shows and museums whenever possible. Look at the canvases and drawings and experience their colors, shapes, and textures. Absorb the total effect the artists are trying to convey. Look at sculpture and pottery and the materials each medium uses. Look at three-dimensional, mixed media modern art. Take a driving tour and experience architecture as art.

Theater is a great inspiration with its costumes, sets, and lighting. Dance and music are important stimuli to creative minds. All of these art forms inspire and excite us. Never underestimate the power and influence of a good concert, theatrical performance, or gallery show. Pay close attention the next time you find yourself at one of these functions and you'll discover what I mean.

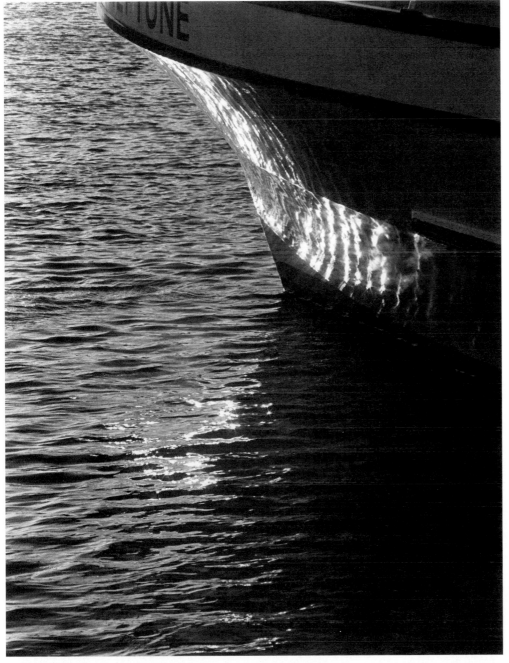

THE NEPTUNE
© Rick Souders

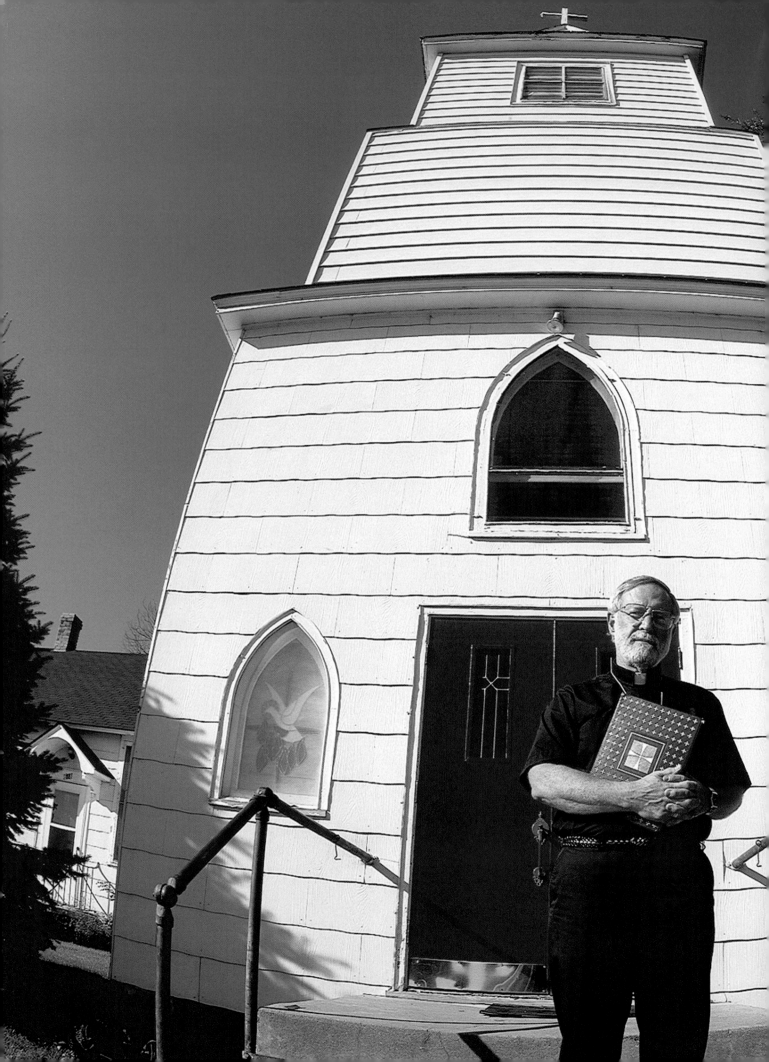

Putting it All Together

Putting together all the elements we've discussed thus far is not an easy task, but it is possible. If you are either plotting the course of a new career in commercial photography or rejuvenating your approach to the career you already have, always remember to set goals and evaluate your level of happiness and satisfaction along the way. Always remember that your success in this field depends not only on being a great visual communicator, but also on whether you are having fun. I don't define success in this book in terms of a particular monetary platform. I don't say, "If you achieve a certain level of income, you can clearly call yourself a success story." I will say instead that you can define success by the amount of fun your job provides you and the amount of satisfaction you receive from your work. Beyond those two very telling indicators, the means by which you define success should only be limited by the scope and range of your own personal goals.

Art, Business, and Personality

Putting the puzzle together is a continual process. You should never stop developing your goals, your career interests, or figuring out what work pleases or displeases you. The following is an oversimplified outline of the steps this book has taken you through. You can copy this page and reuse it as necessary to evaluate where you are on your career path and to redefine where you want to be.

You have wandered through the visual world of commercial photography, glimpsed how to get started, and learned about the art and techniques of lighting and visualization in the first part of this book. In the second half of the book, you ventured through business strategies including communications, pricing, and the art of selling. You have also been exposed to the power of attitude, conviction, perseverance, and passion. The book's goal was to inform you about each of those three separate but related dimensions of this profession.

The first step was learning the art and technique of commercial photography, refining your visualization skills, and learning about lighting, color, and composition, all in an attempt to see the things around you from a new perspective. This ability to see creatively is the source of a photographer's art.

The second dimension of the learning process delineated in this book was business strategy. Quite frankly, most photographers do not focus on developing effective communication skills, pricing, business forms, or ethical means of negotiating deals. They do not master the art of selling. This arena is where most photographers fail. If you devote yourself to learning the business skills outlined in Chapters 7 and 8, you will be several steps ahead of the pack.

The third section of the book (saving the best for last) examined the ways one's personality can effect one's success. I have used the word attitude to define what I perceive as an all-important, enduring quality that will help you achieve your goals. Conviction, perseverance, and passion are all elements of that winning attitude and of what makes you who you are. I cannot overstate the importance of being passionate about what you do. Take the time to look within yourself, and soul-search to find that passion. Working on personal and experimental projects is another fundamental resource for maintaining a fresh interest in and devotion to your work. Exposure to the arts, such as dance, painting, music, and sculpture will also provide you with inspiration. Your attitude defines your style, brings out your individuality, and reveals your unique persective. What I call attitude is an approach that combines your creative visual skills with your intuitive business skills and the unique features of your personality. Strength in those three essential areas—art, business and personality—determines a commercial photographer's success.

YOUR OUTLINE FOR SUCCESS

Research commercial photography options

Research educational and equipment needs

Create goals for setting up shop and getting started

Define your areas of interest

Learn the art and technique of lighting

Set up business practices and forms

Learn pricing, estimating, and customer communications

Develop a portfolio presentation

Create promotional & marketing materials

Learn how to create and maintain a client database

Work on a healthy attitude

Locate and research your desired city

Monitor your goals and progress

Experiment and create personal work

Indulge in the arts

Take risks

Grow and become successful

Always keep your work fun

TAKE A FEW RISKS AND LEARN

I have discussed taking risks within the realm of experimental photography, but you can also take risks in the way you see and conceptualize your work and in your approach to business and the art of selling. If you don't take creative risks as your career develops and progresses, you simply can't learn or grow. Risk challenges you,

strengthens your attitude, and in turn makes you a better visual communicator and businessperson. Taking risks can be scary, but a certain level of fear can be healthy. Think of it this way. If you never took a risk and never tried anything new, wouldn't you be afraid that you could have accomplished great things if you had only tried? Wouldn't that bother you more than the initial fear of taking a risk?

GROW PERSONALLY—ACHIEVE SUCCESS

You have just taken the first step toward change by renewing the way you look at your surroundings. The next steps require you to get in touch with your passion and to build a body of work.

As you continue to grow personally, your level of success will also increase. How we define success is very personal. For me, it means increasing my visual awareness, continually enhancing my business and communications skills, and understanding the importance of attitude and passion. If, when you put this book down, you feel a sense of excitement about what awaits you and a renewed sense of what you want to do with your career, you are well on your way to your own personal definition of success.

Happy shooting.

When we stop seeing, we stop learning. When we stop learning, we stop growing.

SMILE: YOUR NEW JOURNEY HAS JUST BEGUN
© RICK SOUDERS

Index